# OXFORDSHIRE AT WAR

## THROUGH TIME

Stanley C. Jenkins

AMBERLEY PUBLISHING

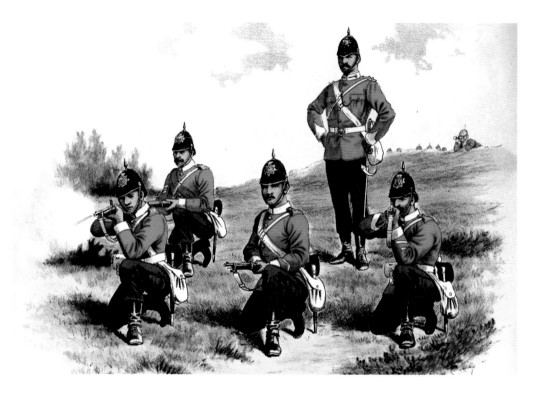

**The Oxfordshire Light Infantry**
A Richard Simpkin print depicting members of the Oxfordshire Light Infantry during the final years of the nineteenth century. The regiment became the Oxfordshire & Buckinghamshire Light Infantry in 1908, by which time it had five battalions – the 43rd and 52nd Light Infantry being the first and second regular battalions respectively, while the 3rd (Special Reserve Militia) Battalion, the 4th Battalion and the Bucks Battalion were the territorial battalions.

First published 2014

Amberley Publishing
The Hill, Stroud, Gloucestershire, GL5 4EP
www.amberley-books.com

Copyright © Stanley C. Jenkins, 2014

The right of Stanley C. Jenkins to be identified as the
Author of this work has been asserted in accordance with
the Copyrights, Designs and Patents Act 1988.

ISBN  978 1 4456 1946 0 (print)
ISBN  978 1 4456 1964 4 (ebook)

British Library Cataloguing in Publication Data.
A catalogue record for this book is available from the
British Library.

Typesetting by Amberley Publishing.
Printed in Great Britain.

# Introduction

In AD 43, the Emperor Claudius ordered the invasion of Britain and dispatched four Roman legions across the Channel – the units concerned being the 2nd Augusta, 9th Hispana, 14th Gemina and 20th Valeria Victrix legions. The 25,000 well-trained heavy infantrymen of these regular legions were supported by a similar number of auxiliaries, including Gallic and Thracian units. Although the Roman invaders met initial resistance in the Medway area, the inhabitants of the Upper Thames Valley appear to have welcomed Roman rule, and there was, in consequence, no conflict between the indigenous Britons and the Roman Army.

The Roman invaders included Lucius Valerius Geminus of the 2nd Legion, who subsequently settled at the Roman military site of Alcester, near Bicester. This Roman soldier is the earliest known inhabitant of what later became the County of Oxford.

The end of Roman rule in AD 410 was followed by a period of turmoil known as the Dark Ages, in which urban life was abandoned and the Upper Thames Valley was colonised by Saxon warriors. The number of invaders must have been relatively small, but the newcomers were able to settle among the Britons and impose their Germanic language and customs upon the earlier Celtic population. The existing Romano-British inhabitants of the district may have been killed or driven away, but it is perhaps more likely that they married and intermingled with the Saxon settlers to create a mixed Anglo-Celtic population.

We know little about military organisation during the Dark Ages, though it seems likely that society would have been organised on a tribal basis, with each community owing allegiance to a local chieftain or warlord. The West Saxon royal family believed that their ancestors had fought several major battles during the sixth century, one of these being in 571 when, according to the Anglo-Saxon Chronicle, a warrior named Cuthwulf defeated the Britons at a place called Biedcanford and captured Aylesbury, Benson, Limbury and Eynsham – thereby starting the long process where the Romano-Britons of the Upper Thames Valley were absorbed into the Kingdom of Wessex.

Further battles took place throughout the sixth century, one of these engagements being at Stoke Lyne in North Oxfordshire where, according to the Anglo-Saxon Chronicle, 'Ceawlin and Cutha fought against the Britons' and Cutha was killed, although the Saxons were ultimately successful and 'Ceawlin captured many vills, and countless spoils, and went away in anger to his own land'. The number of warriors involved in these clashes is likely to have been very small, but the cumulative effects of numerous small skirmishes was significant in that the victorious Saxon warriors became petty kings, and their territory in and around the Upper Thames Valley became the nucleus of the Kingdom of Wessex.

The subsequent development of Saxon Oxfordshire was disrupted by conflict between Wessex and Mercia, with the likelihood that the hilly Wychwood Forest district formed a natural barrier between these rival English kingdoms. In this context, it is interesting to note that Dorchester was the headquarters of the ecclesiastical See of Wessex from 634 until 707, when the See was transferred southwards to Winchester in the face of growing pressure from Mercia. The Upper Thames Valley was, nevertheless, still seen as an area of immense significance to the rulers of Wessex, and, in 752, it is recorded that 'this year Cuthred, King of the West Saxons, in the twelfth year of his reign, fought at Burford against Ethelbald, King of the Mercians, and put him to flight'.

The Battle of Burford is said to have taken place in a field known as Battle Edge. In 1814, a large freestone sarcophagus was discovered on the site, buried some three feet below the surface. It weighed 16 cwt and the feet pointed due south. The cavity was 6 feet in length and a little over 2 feet wide, and it was found to contain the remains of a near-perfect human skeleton and remnants of armour.

At this time, the Midland Kingdom of Mercia was at its peak during the reign of King Offa (757–96) and in 779, it is recorded that Offa attacked the West Saxon stronghold at Benson 'and captured the vill' – the likelihood being that as a result of this victory, the Mercians obtained control of all Wessex lands north of the Thames, and the Oxford area thereby fell under Mercian control.

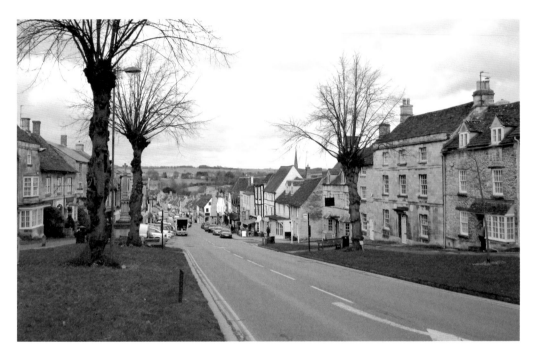

**Burford – The Scene of a Battle Between the West Saxons and Mercians**
A view of Burford's picturesque High Street, looking north towards the River Windrush. The defeat of the Mercians in 752 was, for many years, celebrated on Midsummer Eve by a procession of townsfolk carrying a golden dragon banner.

# Acknowledgements

Thanks are due to Martin Loader (p. 13), Diana Lydiard (pp. 7 and 8), Dino Lemonofides (p. 36) and Col. Tim May (pp. 40 and 63) for supplying photographs used in this publication. Other images were obtained from the Witney & District Museum, the Soldiers of Oxfordshire Trust, and from the author's own collection.

# The Viking Wars
# King Alfred and the Defence of Wessex

In 793, the northern kingdom of Northumbria was attacked by Viking raiders from Denmark. Over the next few years, England was ravaged by waves of Viking invaders who came from across the North Sea to loot and burn towns, villages and monasteries. The first Vikings came to England in search of plunder but, as time went on, it became clear to the horrified English chroniclers that these pagan barbarians intended to conquer the British Isles in their entirety.

In 865, a Danish Great Army, or *Micel Here*, landed in East Anglia, and the invaders systematically destroyed the Anglo-Saxon kingdoms of Northumbria, Mercia and East Anglia over the next few years. Soon, only the south-western Kingdom of Wessex remained under English control.

At the end of 870, the Danes left their fortified camp at Thetford en route for Reading, from where they hoped to launch the long-expected invasion of Wessex. The Anglo-Saxon Chronicle relates that in 871, King Ethelred and his brother Alfred assembled an army and attacked 'the Viking Army of hateful memory' at Reading. The West Saxons suffered an initial defeat, but just four days later, they fought the Vikings at Ashdown and won a major victory; the Chronicle states that a Viking king and five earls were 'cut down on the battlefield, and many thousands on the Viking side were slain there too ... over the whole broad expanse of Ashdown, scattered everywhere, far and wide'.

The Battle of Ashdown was the first large battle fought on open ground between the Vikings and the West Saxons, and it achieved almost mythic status – in part, because it demonstrated that the fearsome Vikings could be defeated. The actual site of the battle remains unclear, though it is generally agreed that 'Ashdown' was a generalised name for the Berkshire Downs.

Two weeks after their victory, Ethelred and Alfred were defeated, while in that same year Ethelred died and Alfred became King of Wessex. His epic struggle against the Danes now commenced and, after several more battles, the West Saxon annals conclude with the observation that 'during that year nine general engagements were fought against the Danish Army in the kingdom to the south of the Thames, besides those innumerable forays which the king's brother Alfred, and a single ealdormen and king's thegns often rode on, which were never counted'.

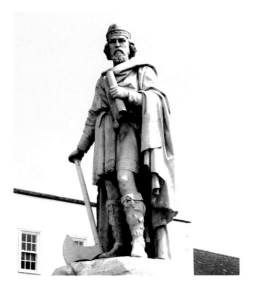

**King Alfred's Statue at Wantage**
Alfred the Great was born in Wantage in 849. In 14 July 1877, a marble statue was unveiled in Market Place, the sculptor being Count Victor Gleichen (1833–91).

# The Viking Wars: The Treaty of Wedmore

In 875, the Danish Army swept through Wessex, hoping to receive reinforcements from Ireland or Scandinavia, but Alfred's forces thwarted these plans and the Vikings were forced to withdraw. In January 878, the Danes, led by a Viking called Guthrum, launched another large-scale invasion of Wessex, and Alfred was forced to take refuge in the Somerset marshes with a small party of household troops. However, in the following spring, King Alfred defeated the Viking Army at Edington, in Wiltshire. The resulting Treaty of Wedmore divided England into two parts – the area to the north and east of Watling Street known as 'The Danelaw' being, in effect, ceded to the Vikings, while the rump of English Mercia was incorporated into an enlarged Wessex, as shown in the accompanying map.

Alfred realised that he could not rely upon the existing military system to counter the continuing Danish threat, and over the next few years he revolutionised English military practice. There was no standing army in England in the Anglo-Saxon era, but in times of national emergency each district was expected to contribute men to a national militia known as 'the Fyrd'. The Anglo-Saxon Chronicle relates that 'the king divided his Army into two so that always half of its men were at home and half on service', and by splitting the Fyrd in this way, Alfred ensured that Wessex would always have an army 'in the field' to deal with Viking attacks.

King Alfred's defence strategy also involved the systematic fortification of his realm, strongholds known as 'burghs' being established at intervals in and around Wessex. In some places, Roman cities were repaired and garrisoned, while elsewhere, Saxon towns were created or adapted for defensive purposes. Some of these fortified burghs were of considerable size and strength. Wallingford, for example, was recorded in a document known as the 'Burghal Hidage' as a stronghold supported by 2,400 tax-raising units known as 'hides', and this implies that it needed 2,400 men to defend a perimeter of 3,300 yards. A total of thirty burghs are mentioned in the Burghal Hidage, and twenty-eight of these have been identified. They include places such as Buckingham, Cricklade, Wallingford, Lydford, Wilton, Tisbury, Porchester, Hastings and Lewes, as well as larger urban centres such as Winchester, Bath, Exeter and Southampton.

In the event of a Viking attack, the Wessex burghs would have required a combined garrison of around 30,000 men, in addition to the mobile field army that would close the gaps between each stronghold, or go on the offensive if necessary. It seems quite clear that forces of this magnitude could not possibly have been sustained by the burghs themselves, and each burgh was therefore placed at the centre of a large tax-raising district, which was charged with providing the necessary garrison on the basis of one man for every hide of land. In this way, the English shires were brought into existence in response to the severe military threat posed by the Vikings.

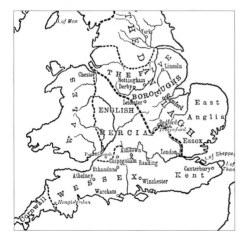

**Wessex and the Danelaw**
A map of England in the ninth century, showing the division between Wessex and the Danelaw.

## The Viking Wars:
## The Foundation of Oxford

Oxford is first mentioned by name in the early tenth century – Oxford itself being laid out as one of the strongly fortified burghs that King Alfred and his descendants created in their campaign against the Vikings, while the surrounding burghal district became the County of Oxfordshire. At that time, Alfred's son, Edward the Elder, and his daughter, Aethelflaed, 'The Lady of the Mercians', were slowly but inexorably recovering English territory from the Danes. Aethelflaed, the widow of a Mercian nobleman who had been entrusted with the defence of London, is likely to have employed her father's engineers to lay out the new burgh on the site of a small, pre-existing settlement.

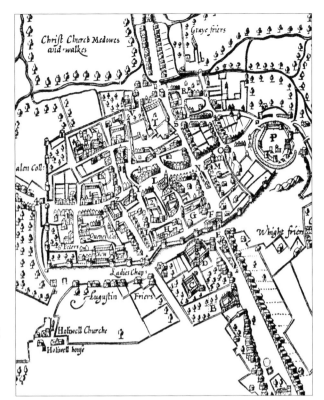

The burgh was encircled by a wall and ditch, while the main streets were laid out in a cruciform arrangement that has survived to the present day. The crossroads at the centre of the Saxon settlement became known as 'Carfax', or the 'Four Ways' (*quatre voies*), the four thoroughfares being Cornmarket, St Aldates, High Street and Queen Street, which extend north, south, east and west respectively toward the long-demolished city gates. The accompanying map shows Oxford during the Tudor period, the city walls being clearly depicted, while Carfax is marked by a letter 'N'.

The photograph shows the ancient tower of St-Michael-at-the-Northgate church, which is believed to have been a watchtower beside the north gate of the Saxon burgh; the doorway that can be seen on the third floor would have provided access to a wall walk.

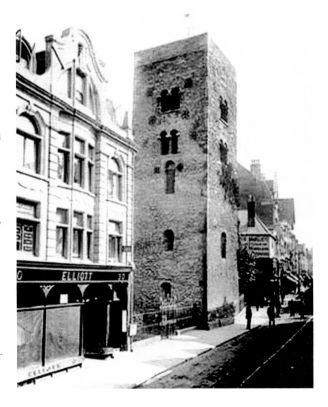

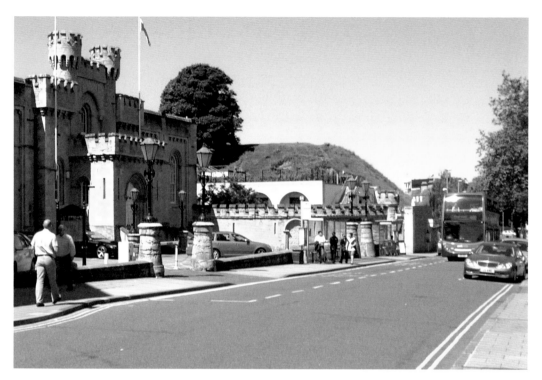

## Medieval Warfare: The Norman Conquest and Oxford Castle

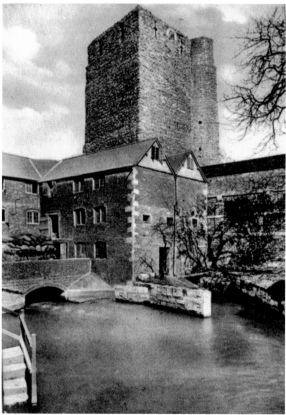

Late Saxon England was undoubtedly one of the richest countries in Europe, and it was perhaps for this reason that it fell into the grasping hands of William the Conqueror. However, William I had at least some claim to the throne, and he was clever enough to adapt the laws and institutions of England to his own needs. The existing system of manors, parishes and shires was retained as the basis of Anglo-Norman rule, and castles were subsequently erected at various places, including Oxford, Wallingford, Deddington, Banbury and Ascot-under-Wychwood. Oxford Castle was founded by Robert D'Oyly, who erected a motte, or castle mound, which was some 259 feet in diameter (*above*). The keep, and other buildings, originally of timber, were later replaced by permanent stone-built structures, such as St George's Tower (*left*).

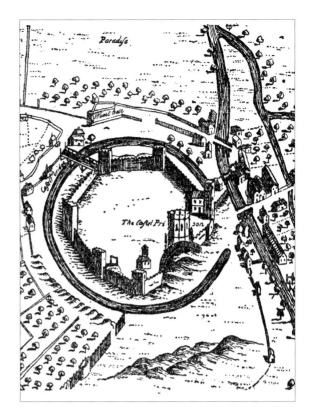

## Medieval Warfare:
### Further Details of Oxford Castle

*Above*: A map surveyed by the pioneer mapmaker Ralph Agas (*c.* 1540–1621). The castle was a roughly circular fortress, with a tall stone keep on top of the castle mound. Most of it was dismantled after the Civil War, but a prison and county court were built on the site during the 1840s. *Below*: Five of the castle's six mural towers have been destroyed, but St George's Tower remains extant. It was, at one time, believed that the tower was of Saxon origin, while others have suggested that it may have been erected by the Normans to serve as a rudimentary keep, because the earth of the newly raised motte was unable to bear the immense weight of a stone building. Although clearly of military origin, the tower also functioned as the bell tower of the long-demolished castle chapel. *Inset*: The castle in 2012.

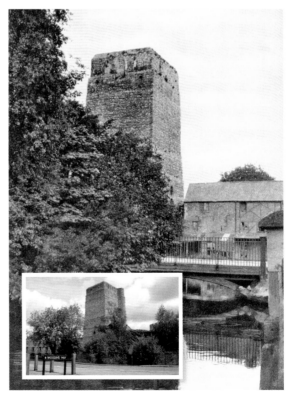

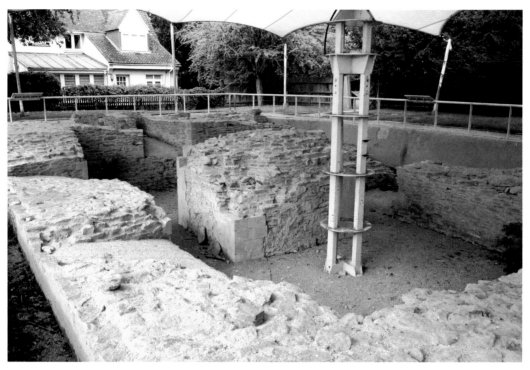

## Medieval Warfare: Adulterine Castles and 'The Anarchy'

Henry I, the Conqueror's youngest son, died in 1135, having nominated his daughter, the Empress Matilda, widow of the German emperor, as his successor. However, the barons decided that a mere woman was unfit to rule, and offered the crown instead to Stephen de Blois, the late King's favourite nephew. This led to a civil war known as 'The Anarchy', in which the Anglo-Norman landowners erected private castles – many of which were 'adulterine' or unlicenced. At Witney, for example, the Bishop of Winchester transformed his manor house into a walled and moated castle with a gatehouse and tower keep, while Aylmer de Valence turned his house at Bampton into a castle with corner towers and two gatehouses. The sepia print provides an impression of the half-ruinous Witney 'castle' during the eighteenth century, while the colour photograph shows the foundations of the Norman keep in 2013.

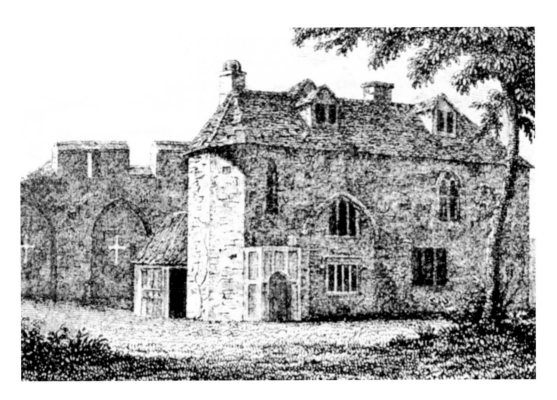

## Medieval Warfare: Military Action at Radcot, Bampton and Wallingford

The writer of a contemporary document known as the *Gesta Stephani* states that in 1141 the Empress Maud erected a castle at Radcot, surrounded by water and marshes. It is thought that this castle was sited near Radcot Bridge in a field known as 'The Garrison', the likelihood being that the structure was a rectangular Anglo-Norman 'tower house' – similar to the fortified keep that had been constructed by Henry de Blois at neighbouring Witney. In 1142, the castles at Radcot and Bampton were attacked, and a battle took place around the bridge at Radcot, while Wallingford Castle, which was stubbornly held for the Empress by Brian FitzCount, was under more or less continuous siege throughout the period of 'The Anarchy'. The sepia print shows the remains of Bampton Castle, and the colour photograph shows the same building, now known as Ham Court, from a different angle.

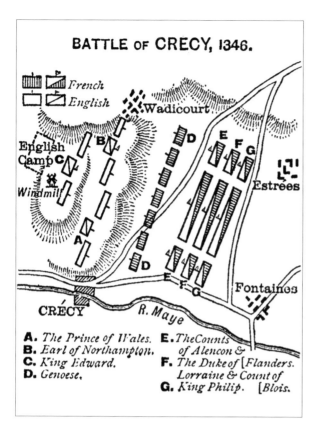

# BATTLE of CRECY, 1346.

French
English

Wadicourt

English Camp

Windmill

Estrees

CRÉCY

R. Maye

Fontaines

**A.** *The Prince of Wales.*
**B.** *Earl of Northampton.*
**C.** *King Edward.*
**D.** *Genoese.*
**E.** *The Counts of Alencon &*
**F.** *The Duke of [Flanders. Lorraine & Count of*
**G.** *King Philip.* [Blois.

Medieval Warfare: The Battle of Crécy and the Hundred Years War

Edward III held land in France, and this gave him an excuse to claim the French throne, starting the Hundred Years War between England and France. In 1346, Edward invaded France with 19,000 men. On 26 August, this comparatively small force defeated a French Army of at least 70,000 men at Crécy. The battle resulted in the total destruction of the French Army, thousands of men and horses being struck down by the English arrows, which fell from the sky like 'flakes of snow'. Those taking part in the battle included the King's son Edward, the Black Prince, who had been born at Woodstock in 1330. Another Oxfordshire participant was Lord Grey of Rotherfield (1300–59), who fought at Crécy in the King's Division, and took part in the siege of Calais a year later in the retinue of William Clinton, Earl of Huntingdon. The battle plan is taken from a Victorian textbook printed in 1895, while the engraving shows an ancient building in Woodstock that was said, erroneously, to have been 'the residence of the Black Prince'.

## Medieval Warfare: The Second Battle of Radcot Bridge

Oxfordshire was the scene of military activity during the reign of Richard II, whose rule was marred by plots and rebellions. In December 1387, the King's opponents, who called themselves the 'Lords Appellant', marched on London. The King's favourite, Robert de Vere, attempted to stop the rebels, but his force of about 5,000 men was defeated by Henry Bolingbroke at Radcot Bridge on 19 December 1387. Bolingbroke is said to have broken down the centre arch of the bridge, while legend suggests that de Vere escaped by jumping, fully armoured, into the Thames on his horse. The picture above shows the area known as 'The Garrison', where the battles of 1141 and 1387 are alleged to have been fought. The view on the right shows the old triple-arched bridge – its centre arch is of later construction than the flanking arches, suggesting that it may indeed have been broken down in 1387.

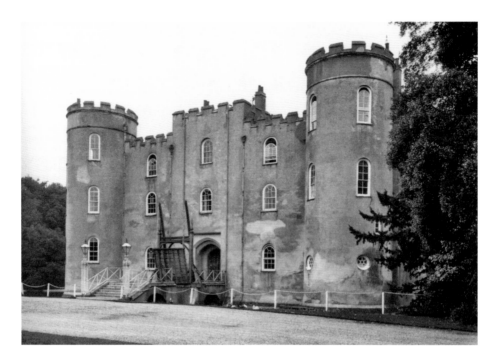

Medieval Warfare: Shirburn Castle

Most of Oxfordshire's castles have been dismantled, but the county has retained two lake castles, both of which originated as fortified manor houses. Shirburn Castle, in the south of the county, is a quadrangular, fourteenth-century castle with round corner towers. It was purchased by the Earl of Macclesfield in 1716, and in the ensuing years the building was adapted for domestic use. The photographs show the castle in the 1920s; it is not open to the public.

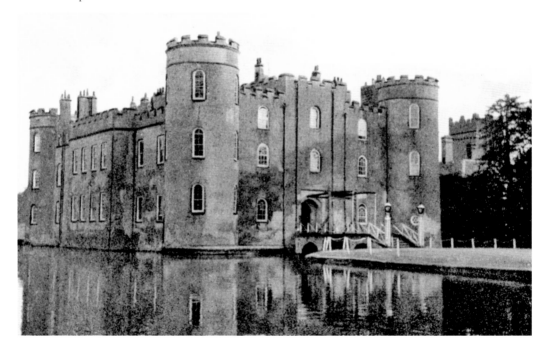

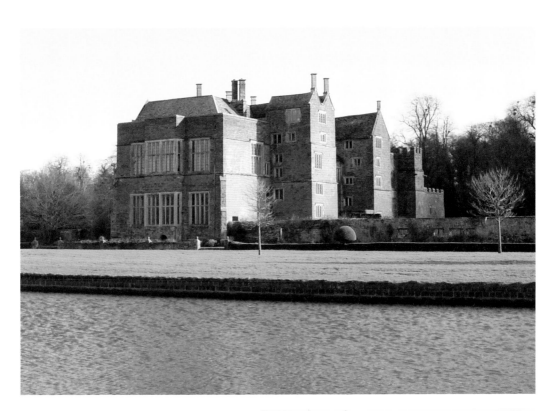

## Medieval Warfare: Broughton Castle

Broughton Castle, the ancestral home of the Fiennes family, was built in the early fourteenth century, when Sir John de Broughton obtained a licence to crenelate his manor house. The castle subsequently passed by marriage to Sir William Fiennes, whose descendants transformed the building into an Elizabethan mansion. At the start of the Civil War, the castle was held for Parliament by William Fiennes (1582–1662), also known as Lord Saye and Sele, a leading opponent of King Charles I. However, shorn of its defences, Broughton was unable to withstand a siege, and the castle was surrendered to the Royalists after the Battle of Edge Hill. The sepia view, dating from the 1920s, shows the fourteenth-century gatehouse, which was retained as an ornamental feature when the castle was 'demilitarised'. The colour photograph, taken in 2013, shows the south-facing façade, which features two massive stair towers.

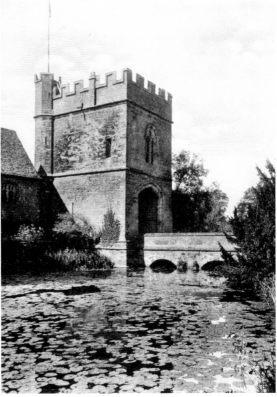

## Medieval Warfare:
## The Battle of Agincourt

The Hundred Years War, which had been in fitful progress since 1338, was still being waged during the early years of the fifteenth century, and in 1415, Henry V landed in Normandy and captured Harfleur. Henry's army was subsequently caught by a vastly superior enemy force at Agincourt. But, as on previous occasions, the heavily outnumbered English archers destroyed the French Army. Henry's senior officers included Lord Camoys, whose family was associated with Stonor Park, near Henley-on-Thames. The illustration (*left*) depicts a fifteenth-century mounted knight wearing full plate armour, while the lower picture shows the disposition of the English and French armies at the start of the battle.

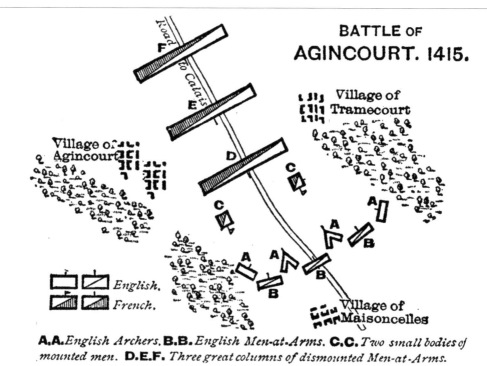

**BATTLE OF AGINCOURT. 1415.**

Road to Calais

Village of Tramecourt

Village of Agincourt

Village of Maisoncelles

English.
French.

**A.A.** *English Archers.* **B.B.** *English Men-at-Arms.* **C.C.** *Two small bodies of mounted men.* **D.E.F.** *Three great columns of dismounted Men-at-Arms.*

## Medieval Warfare:
## The Wars of the Roses

The period of political upheaval known as the Wars of the Roses had little effect upon Oxfordshire, despite the participation of local magnates such as Sir Robert Harcourt and Lord Francis Lovell. There is no evidence of military conflict within the county, although in 1469, a Lancastrian force led by Robin of Redesdale defeated the Yorkists at Edgecote Moor in Warwickshire, about five miles to the north-east of Banbury. The upper view shows part of Stanton Harcourt manor house – the home of Sir Robert Harcourt, who was standard bearer to Henry VII at the Battle of Bosworth. The lower photograph depicts the south-west tower of Lord Francis Lovell's house at Minster Lovell. Lord Francis, the 9th Baron Lovell, had been a favourite of the Yorkist King Richard III and together with Richard's two other favourites, Sir William Catesby and Sir Richard Ratcliffe, these three Yorkists effectively ruled England. This gave rise to the following 'political' rhyme: 'The Cat, the Rat and Lovell the Dog,/ Ruleth all England under the Hog'. The 'Hog' being King Richard himself, whose crest depicted a white boar! Sadly, the shifting sands of national politics meant that Lord Lovell found himself on the losing side after the Battle of Bosworth in 1485; King Richard was killed by his Lancastrian enemies, while Francis Lovell was forced to flee to Flanders.

## Medieval Warfare: The Mysterious Fate of Lord Francis Lovell

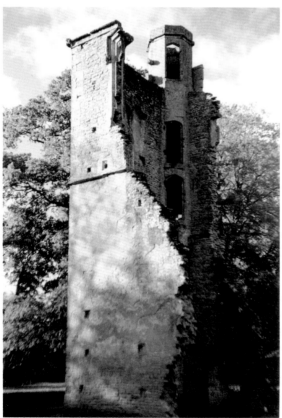

Two years after the Battle of Bosworth, Lord Lovell attempted to place a youth called Lambert Simnel on the throne, on the pretext that he was a legitimate Yorkist heir. An invasion force was assembled in Ireland and the Yorkists, led by Lord Lovell, advanced through the Midlands to Stoke, near Newark, where they were defeated by Henry VII. Some sources claim that Francis Lovell was killed in the battle, but local tradition asserts that he returned to his house at Minster Lovell (*above and left*), where he was concealed in a secret chamber known only to one faithful servant. However, the elderly servant died, and Lord Lovell starved to death within the hidden chamber. The story was taken up by John Buchan in his novel *The Blanket of the Dark* (1931), which describes the discovery of a dead man, his eyes 'shrunk to things like dried berries, the skin, grey and wrinkled', still hanging to the bones.

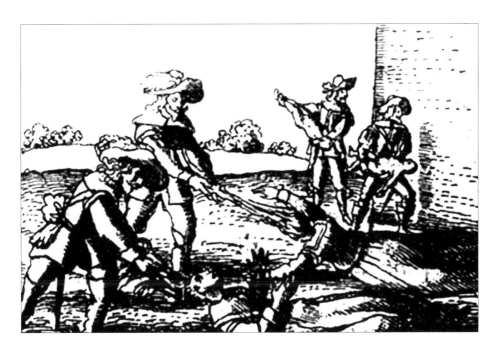

### The Civil Wars: Rebellion in Ireland and the Road to War

In November 1640, King Charles I called a parliament after years of personal rule. This led to confrontation between the King and much of the political establishment, and civil war seemed inevitable. A Royal attempt to enforce episcopacy in Scotland resulted in the defeat of an English Army at Newburn, and a Scottish invasion of England. While in 1641, a great rebellion broke out in Ireland. As the King and Parliament argued about who was to control the army that would subdue the rebels, terrified Protestants fled from Ireland, spreading horrific stories of sectarian massacres. One of these Protestant refugees is recorded in Witney during the winter of 1641/42. Against this background of rising hysteria, the King and his opponents began preparations for war. The upper picture purports to show Protestant Irishwomen being dragged by their hair while their babies are brutally murdered, while the lower view depicts King Charles.

19

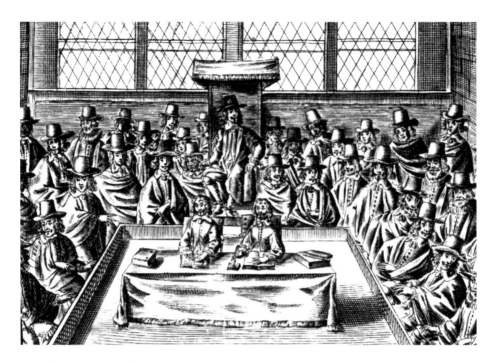

### The Civil Wars: Speaker Lenthall and Burford Priory

The sympathies of Oxfordshire as a whole were probably with Parliament. Many Parliamentary leaders, including John Hampden (1594–1643), William Lenthall (1591–1662), and Lord Saye and Sele, resided within the county, or had properties in the area. In September 1642, William Lenthall, the Speaker of the Long Parliament, famously defied King Charles by refusing to hand over five MPs who had been accused of 'treason'. The engraving shows William Lenthall in the Speaker's Chair, while the photograph shows Burford Priory, his house at Burford.

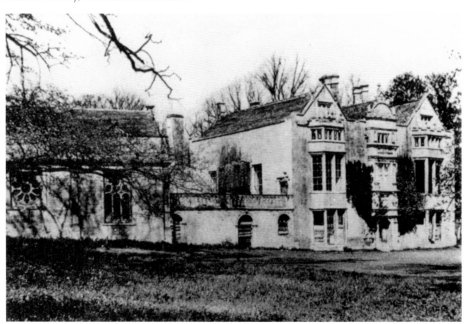

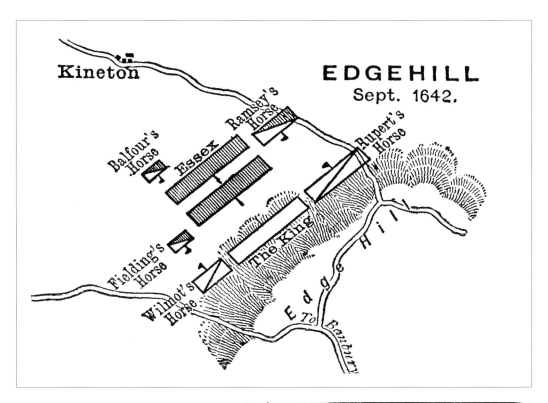

## The Civil Wars:
## The Battle of Edge Hill

The first large-scale Civil War battle, which took place at Edge Hill on 22 August 1642, was inconclusive, but it enabled the King to set up his wartime capital in Oxford. For the next four years, Oxford was in a state of semi-siege, though the Parliamentarians made no attempt to storm the city. The plan of the battlefield is from a Victorian history book, while the lower illustration depicts Prince Rupert (1619–82), the King's nephew, and Royalist cavalry commander.

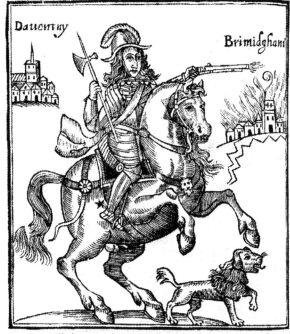

The moſt Illuſtrious and High borne PRINCE RUPERT, PRINCE ELECTOR, Second Son to FREDERICK KING of BOHEMIA, GENERALL of the HORSE of H's MAJESTIES ARMY, KNIGHT of the Noble Order of the GARTER.

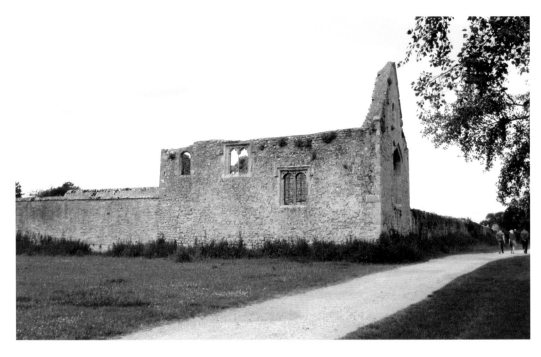

## The Civil Wars: Royalist Outposts Around Oxford

The city was extensively fortified by a sophisticated system of earthwork bastions, together with an outer ring of detached outposts at places such as Woodstock Palace, Godstow Nunnery, Bletchingdon House and Gaunt House – a large moated house near Standlake, which was the home of Samuel Fell, an ardent Royalist and the Dean of Christ Church Cathedral, Oxford. The upper picture shows Godstow Nunnery, while the lower view shows Civil War enthusiasts in period costume.

## The Civil Wars: The Battle of Chalgrove Field and the Death of John Hampden

On 17 June 1643, Prince Rupert left Oxford with 1,600 men in order to intercept enemy convoys and carry out attacks on Parliamentarian outposts. That night, Rupert's men looted and burned the villages of Postcombe and Chinnor, and killed about fifty Roundheads before returning towards Oxford. The raiders were closely followed by a force of avenging Parliamentarians, and Rupert, fearing that his rear would be overwhelmed, turned and charged. The resulting clash between Rupert's raiding party and the Roundheads was centred on a hedge to the south of Chislehampton Bridge, which had been seized by some Parliamentarian dragoons. The skirmish, known as the Battle of Chalgrove Field, resulted in the death of Parliamentary hero John Hampden, who was 'shot into the shoulder with a brace of bullets' and rode off 'with his head hanging down, and his hands resting on the neck of his horse'. He died at Thame a few days later, his untimely death being regarded as a 'glorious crown of victory' by the Royalists, while Oliver Cromwell remembered him as 'a very worthy friend' and 'a wise and worthy person'. The colour photograph shows John Hampden's monument on the site of the battlefield at Chalgrove, while the sepia picture, entitled *The Death of Hampden*, is taken from a print published in 1846; some of the helmets depicted in this illustration are of curious design, and probably owe much to Victorian imagination!

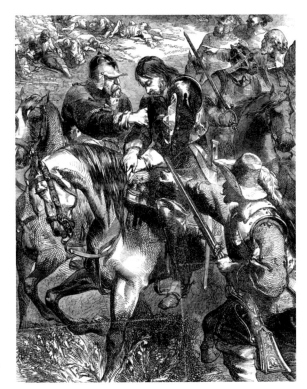

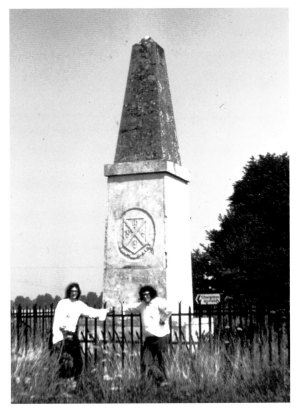

## The Civil Wars:
## Prisoners at Witney

By 1643, Royalist victories elsewhere in the country had resulted in Oxford becoming a place of incarceration for Parliamentarian prisoners, and it is recorded that after the capture of Cirencester, over 1,000 prisoners were roped together and marched barefoot to Oxford, being confined in various churches en route. At Witney, the strongly Protestant townsfolk attempted to feed the prisoners through the windows of the parish church, but the Royalist soldiers drew their weapons and callously prevented this small act of mercy. The King, angry because his rebellious Witney subjects had been 'over kind to the Cirencester prisoners', showed his displeasure by demanding cloth for his soldiers from every clothier in the town. The pictures show St Mary's church in more peaceful times around 1920 (*left*) and in September 2013 (*below*).

## The Civil Wars: The Battle of Cropredy Bridge

In June 1644, King Charles left his headquarters at Oxford with 6,000 men, accompanied by 'two pieces of cannon and thirty coaches'. Travelling via Hanborough, the King's Army marched to Witney, where it was joined by other Royalist forces. The combined force then moved northwards via Woodstock to meet Gen. Waller's Parliamentarian Army at the Battle of Cropredy Bridge on Saturday 29 June 1644.

Two Parliamentarian regiments had crossed from the west to the east bank of the Cherwell in order to engage the rear of the King's Army, and for a time the Parliamentarians were successful, but the main body of the Royalist force then appeared on the scene, and Waller was forced back across the river. The King himself arrived 'about five of the clock, and drew us off the top of a hill', recalled the diarist Richard Symonds, a member of the King's Army; it was at first thought that Waller had been killed 'but it proved a lye'.

As afternoon turned to evening, the rival forces were still in the field; the Royalists being on the east bank of the river with their headquarters at Williamscott, while the Parliamentarians occupied the high ground around Hanwell and Bourton. This situation continued throughout the following Sunday, but as evening approached the King received news that Parliamentary reinforcements were approaching, and on Monday 1 July, the Royalists withdrew in good order. The unfortunate Gen. Waller, who had lost his artillery and seen many of his men run away, made no attempt to pursue the enemy, although at the end of the battle his own forces still held the disputed bridge. The upper picture shows the bridge around 1912, while the lower illustration is a reasonably accurate likeness of Sir William Waller.

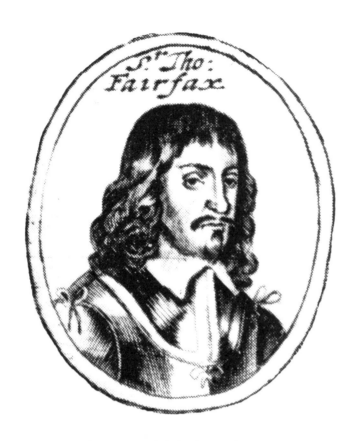

## The Civil Wars: The Formation of the New Model Army

The lack of commitment that had been displayed by Gen. Waller's soldiers was only too obvious to Oliver Cromwell, who described many of the Parliamentary soldiers as 'old decayed serving-men, and tapsters and such kind of fellows'. The Royalists, in contrast, included 'gentlemen's sons, younger sons and persons of quality'. In order to win the war, the Parliamentarians would require 'men of a spirit' who would 'go on as far as gentlemen will go'. Cromwell found such men in abundance in his native East Anglia, and among the ranks of the Puritans. There were already large numbers of Puritans within the Parliamentarian forces, and these God-fearing men formed the basis of Parliament's formidable New Model Army, which was formed in January 1645. The upper picture shows General Sir Thomas Fairfax (1612–71), the commander of the new force, while the lower view provides a glimpse of a Civil War re-enactment in 1970.

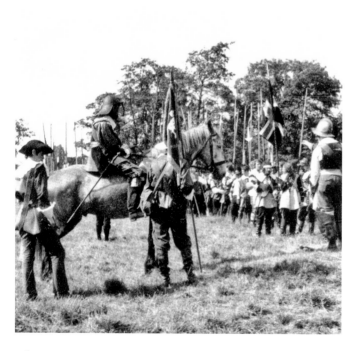

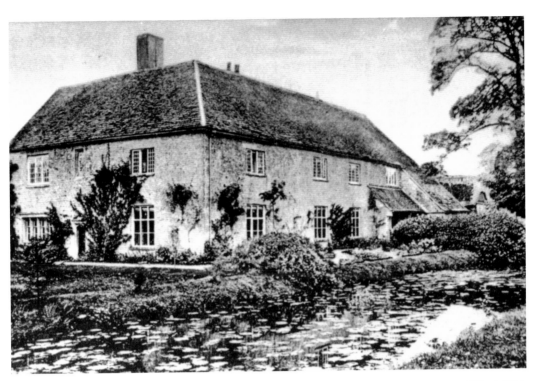

## The Civil Wars: The Engagement at Islip Bridge

In April 1645, Cromwell was sent to Oxfordshire to eliminate the Royalist garrisons around the city and prevent the King from joining forces with Prince Rupert. On Thursday 24 April 1645, the New Model cavalry attacked three Royalist regiments at Islip Bridge and put them to flight. Cromwell reported that 'they made a total rout of the enemy, and had the chase of them for three or four miles, and killed two hundred, took as many prisoners and about four hundred horses'. Gaunt House, shown in the upper view, surrendered to Col. Thomas Rainsborough in the following May after a three-day siege; cannon balls found in the moat suggest that it had been subjected to a considerable artillery bombardment. The lower pictures, both contemporary, show Oliver Cromwell and Col. Rainsborough – Cromwell's image bears little resemblance to the Parliamentary general.

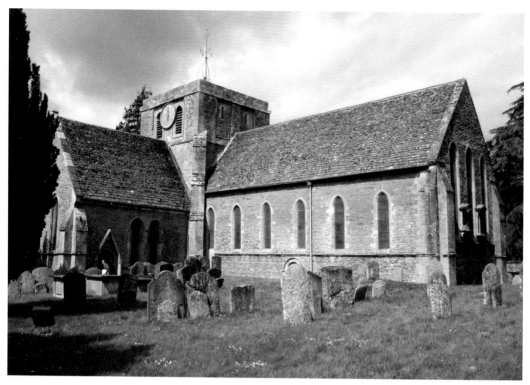

## The Civil Wars:
## Military Activities at Faringdon

Faringdon, on the south side of the Thames (and then in Berkshire), had been occupied by the Royalists in 1644, prompting a lightning raid by Oliver Cromwell in April 1645, and a further attack by Sir Robert Pye (1622–1701) in the following year. Sir Robert, a prominent local Parliamentarian who had married John Hampden's sister, had the satisfaction of ejecting the Royalists from Faringdon House, which had been his own home prior to the war. During the course of these operations, the parish church was damaged by artillery fire and its spire was destroyed – which explains the present 'stumpy' appearance of the tower, as revealed in the accompanying illustrations!

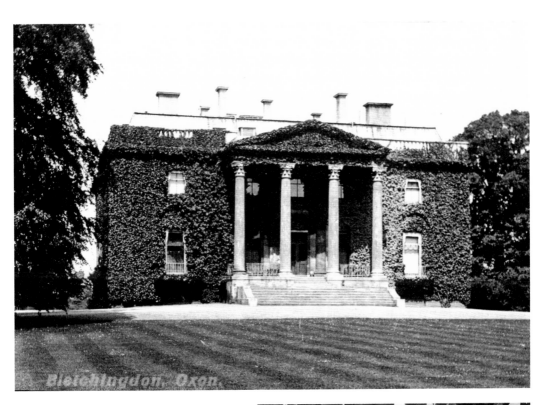

## The Civil Wars: The Sad Fate of Colonel Windebank

Following his success at Islip on 24 April 1645, Cromwell chased the defeated Cavaliers to Bletchington and demanded the surrender of Bletchington House, a Royalist outpost commanded by Col. Francis Windebank, the son of the King's Secretary of State. Col. Windebank, who had several women and children within the house, including his young wife, immediately surrendered, the garrison being allowed safe conduct to Oxford. The upper view shows the present Bletchington House, which was erected in the eighteenth century, long after the Civil War. Ironically, Cromwell had not intended to storm the building, 'it being strong and well-manned, and in any case none of my business'. Sadly, Col. Windebank was later court marshalled and shot, possibly in Christ Church Meadow, against the wall of Merton College; his ghost is said to haunt Dead Man's Walk, shown on the right.

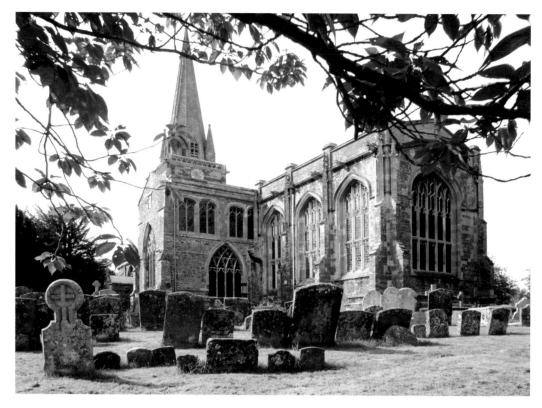

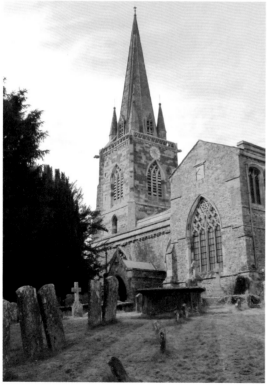

### The Civil Wars:
### The Death of William Oldys

The Civil War, which divided families and pitted neighbour against neighbour, enabled a variety of old scores to be settled. Something of this nature appears to have taken place at Adderbury, where the vicar, the Revd Doctor William Oldys (*c.* 1599–1645), a staunch Royalist, was obliged to go into hiding in Banbury. Betrayed by one of his enemies, he was pursued by Roundheads while conducting his wife and son to Winchester, and shot dead by one of the Parliamentarian soldiers – allegedly one of his own parishioners. The photographs show St Mary's church, Adderbury, which contains the grave of the murdered vicar.

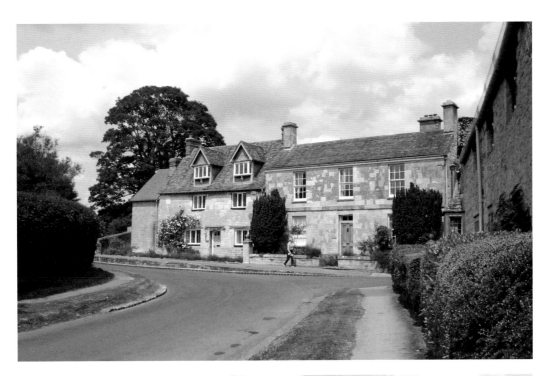

## The Civil Wars:
## The End of the First Civil War

One by one, the Royalist garrisons around Oxford were reduced. Woodstock capitulated on 26 April, while 200 prisoners were captured at Bampton on 26 April. Banbury was liberated on 8 May, and on 24 June 1646, Oxford surrendered without bloodshed, and the first Civil War came to an end. The surrender negotiations took place in the building known as 'Cromwell's House', in Old Marston, which is shown in the photographs. The defeated Cavaliers were well treated by the victorious Parliamentarians, many Royalist soldiers being given cash payments in order that they could make their way back to their homes. *Inset:* The blue plaque that was affixed to Cromwell's House in 2013.

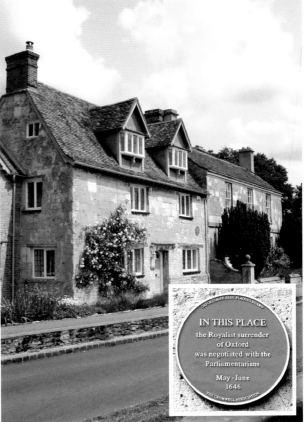

IN THIS PLACE
the Royalist surrender
of Oxford
was negotiated with the
Parliamentarians

May–June
1646

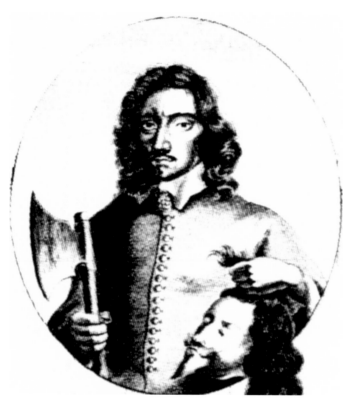

## The Civil Wars: The Second Civil War (1648)

It was hoped that the King and Parliament would be able to settle their differences after the Civil War, but sadly, this did not happen, and King Charles led his followers into the Second Civil War, which lasted from 28 April 1648 until 28 August. The Second Civil War had little immediate effect on Oxfordshire, but the area was troubled by former Royalist soldiers who became highwaymen after the surrender of Oxford. In May 1647, the Sheriff of Oxfordshire was forced to raise a *posse comitatus* to apprehend 'many troopers, Irish and others', who had recently been in arms against Parliament, and were now robbing innocent travellers. Having lost the Second Civil War, King Charles was put on trial as an enemy of the people. Having been found guilty of high treason, the hapless monarch was beheaded in London on 30 January 1649 (*above*). On 19 May, England was declared 'A Commonwealth and Free State' by the authority of 'the representatives of the people in Parliament'. *Left:* The arms of the Commonwealth, which depicted the conjoined arms of England and Ireland.

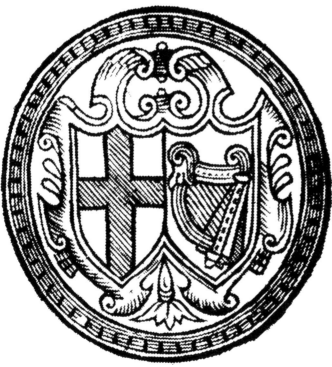

**The Civil Wars: The Levellers' Mutiny**

The creation of the Commonwealth was welcomed by the rank-and-file Parliamentarian soldiers, who had always considered themselves 'no mere mercenary Army' but as citizens in arms, 'called forth and conjured by the several declarations of Parliament' for the defence of their own and the people's just rights and liberties. Some of the more radical soldiers demanded the right to vote, these early democrats being known as the 'Levellers'.

In May 1649, Col. Scrope's regiment mutinied in Salisbury and marched towards Burford, where they were joined by other Leveller activists and occupied the town. Gen. Fairfax stamped out the mutiny and around 400 mutineers soon found themselves locked-up in Burford church. On 19 May 1649, Cornet Thompson, Cpl Perkins and Pte John Church were put against the churchyard wall and shot. *Right:* The church in which the Levellers were incarcerated. *Below:* A plaque on the church wall commemorates the Leveller soldiers who were shot for mutiny.

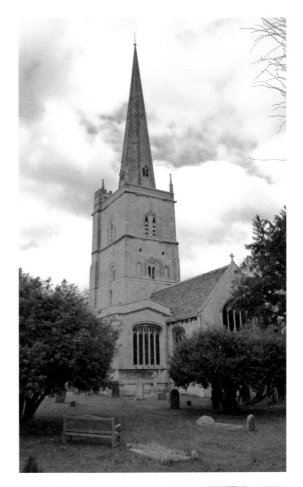

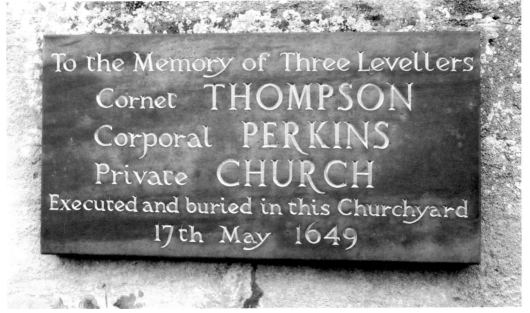

To the Memory of Three Levellers
Cornet THOMPSON
Corporal PERKINS
Private CHURCH
Executed and buried in this Churchyard
17th May 1649

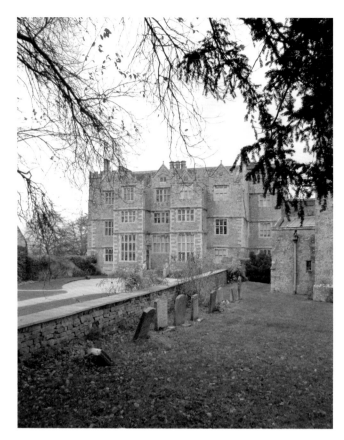

## The Civil Wars: Arthur Jones and the Battle of Worcester

Many Royalists regarded the Prince of Wales (the future Charles II) as their uncrowned king, and this led to further military activity in the summer of 1651, when Charles led a Scottish Army into England. In the event, the invaders were utterly routed by Oliver Cromwell at the Battle of Worcester on 3 September 1651. Arthur Jones of Chastleton House, who had been an officer in the Scottish invasion force, became a fugitive after the battle. He returned to Chastleton with a party of Roundheads in pursuit and concealed himself behind some panelling in a chamber, which, in later years, was dubbed 'The Cavalier's Room'. His wife Sarah told the Parliamentarian soldiers that she was alone in the house, but when they noticed a tired horse in the stables they insisted on spending the night in 'The Cavalier's Room'. Unperturbed, Sarah Jones sent them a supper laced with drugs, and when the soldiers were in deep sleep she released her husband from his secret hiding place and thereby facilitated his escape. The accompanying photographs show Castleton House in November 2012.

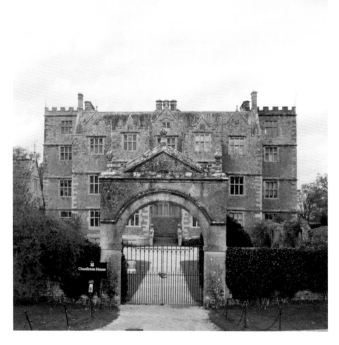

## The Civil Wars:
### Oliver Cromwell and the Protectorate

In April 1653, the 'Rump' of the Long Parliament, which had been sitting since 1641, attempted to perpetuate itself without re-election. Determined that Parliament should not be allowed to act in this unconstitutional way, Cromwell dissolved Parliament and established himself as the 'Lord Protector of the Commonwealth of England, Scotland and Ireland and the dominions thereto belonging'. For the next five years, the British Isles were ruled by Cromwell and his Council of State – attempts to establish new parliaments in 1653 and 1654 having proved abortive.

Oliver Cromwell died at the height of an apocalyptic thunderstorm on 3 September 1658 – the anniversary of two of his greatest victories at Worcester and Dunbar. His well-meaning but ineffective son Richard was unable to govern the country, and when it became clear that restoration of the Monarchy was the only viable option, General George Monck, the commander of the Army in Scotland, entered England with 6,000 men and called for the election of a Free Parliament – the result being the triumphant return of King Charles II as a monarch with strictly limited powers, who would rule in conjunction with Parliament.

The Restoration settlement entailed the demobilisation of the Cromwellian Army, although Monck's own regiment was retained, together with one Royalist regiment – these two units being the ancestors of the Coldstream and Grenadier Guards respectively. The illustrations show Gen. Monck (*above*), and the cap badge of the Coldstream Guards (*right*), which is in effect the last surviving regiment of Cromwell's army.

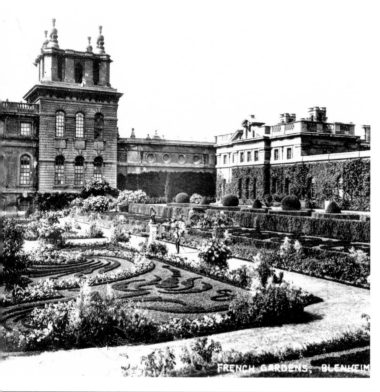

FRENCH GARDENS, BLENHEIM

## Oxfordshire's Greatest Soldier Wins the Battle of Blenheim

John Churchill, Duke of Marlborough, was perhaps Oxfordshire's greatest soldier. His stunning victory at the Battle of Blenheim in 1704 saved Austria from the French, and humbled the over-mighty Louis XIV. A grateful nation rewarded Marlborough by giving him the royal manor of Woodstock, and a grant of £500,000 to build a Baroque palace that would rival Versailles. Designed by Sir John Vanbrugh and Nicholas Hawksmoor, Blenheim Palace eventually cost around £300,000, much of this sum having been provided by the Duchess of Marlborough because only half of the money voted by Parliament was ever paid. The completed palace is replete with military symbolism, its external ornamentation being composed chiefly of spears, flags and cannon balls, while the rectangular plan of the main block, with its four massive towers, resembles that of a fortress. The upper view shows the east Formal Garden around 1912, and the colour photograph was taken in 2006.

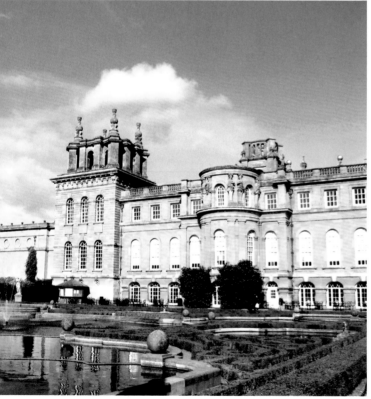

## Origins of the Local Regiment: The 43rd and 52nd Regiments of Foot

It soon became apparent that the Restoration settlement had reduced the Army to such an extent that it was no longer viable, and in order to rectify this deficiency, additional regiments were formed during the seventeenth and eighteenth centuries. One of these new regiments, known as Thomas Fowke's Regiment of Foot, was raised in 1741, at the start of the War of the Austrian Succession, its headquarters being at Winchester. Thomas Fowke was subsequently replaced as colonel of the regiment by William Graham, who was in turn replaced by Col. James Kennedy. The War of the Austrian Succession ended in 1748, and several regiments were then disbanded. As a result of these changes, Col. Kennedy's regiment, which had hitherto been designated the 54th Regiment, became the 43rd Regiment of Foot. Another regiment, also known as the 54th Regiment of Foot, was raised in Coventry in November 1755, its first colonel being Col. Hedworth Lambton. The new regiment was one of eleven infantry regiments raised at a time of growing tension between Britain and France, particularly in North America. In 1756, Col. Lambton's regiment was designated the 52nd Regiment of Foot. The illustrations show a soldier of around 1745 (*above*), and a soldier of around 1780 (*right*).

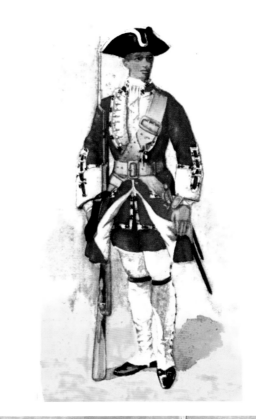

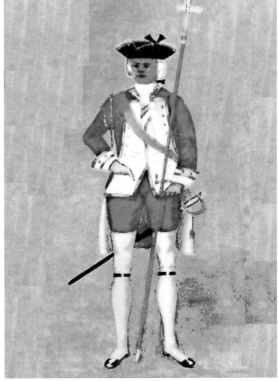

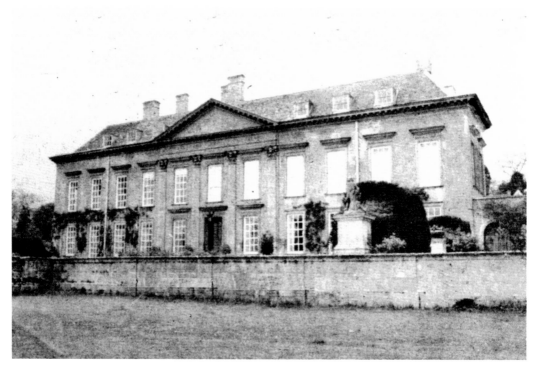

## The Jacobite Rising and Jacobite Plotting at Cornbury

In July 1745, Charles Edward Stuart (1720–88), 'The Young Pretender', landed in Scotland and raised the clans. A government force commanded by Sir John Cope was defeated by the rebels at Prestonpans, and the Jacobites advanced south into England. However, having reached Derby, Bonny Prince Charlie realised that he had little support in England, and returned to Scotland, his army being annihilated at the Battle of Culloden. Oxfordshire has two links with the 1745 Rebellion. The hapless Sir John Cope (1690–1760) lived at Bruern Abbey near Kingham, while Lord Cornbury (1710–53) was a Jacobite sympathiser who made his home at Cornbury Park (*above*) into a centre of Jacobite intrigue. There is a tradition that Jacobite fugitives were concealed at Cornbury after the rising. Less plausibly, Bonny Prince Charlie (*left*) is said to have visited the house in disguise!

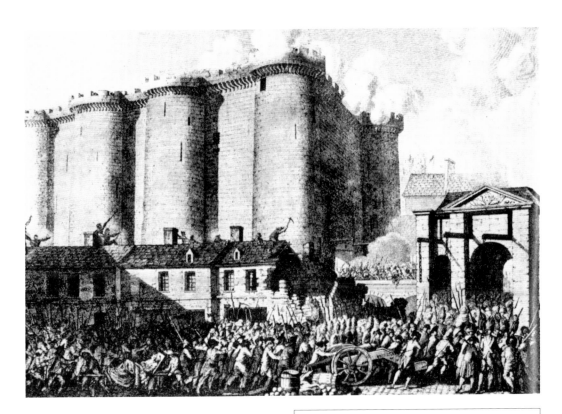

## The French Wars: The French Revolution and the Start of the Wars

In May 1789, King Louis XVI, facing national bankruptcy, summoned the French States-General, or parliament, for the first time in two centuries, but this incompetent monarch was unable to control the democratic forces that he had unleashed. When the King threatened to use force against them, a Parisian mob stormed the Bastille, thereby starting the French Revolution (*above*). Louis was guillotined on 21 January 1793, and on 8 February, the French National Convention declared war on Britain. By March, France was at war with most of Europe. At first, many British people approved of the revolution, but as the events in France descended into bloodshed and terror, public opinion shifted perceptibly. Order was eventually restored by Napoleon Bonaparte, a brilliant Corsican artillery officer, who became First Consul of France in 1799. By that time, the war had developed into a mortal struggle between Britain and France. *Right:* A hand bill warns against the Napoloenic threat.

# Who is Bonaparte?

WHO IS HE? Why, an obscure Corsican that began his Murderous Career, with turning his Artillery upon the Citizens of Paris—who boasted in his Public Letter from Pavia, of *having shot the whole Municipality*—who put the *helpless, innocent*, and *unoffending* Inhabitants of Alexandria, *Man, Woman*, and *Child*, to the SWORD, till *Slaughter* was tired of its Work—who, against all the Laws of War, put near 4000 Turks to Death, in cold Blood, after their Surrender—who destroyed his own Comrades by *Poison*, when lying sick and wounded in Hospitals, because they were unable to further the Plan of Pillage which carried him to St Jean D'Acre—who, having thus stained the Profession of Arms, and solemnly and publicly renounced the religious Faith of Christendom and embraced Mahometanism, again pretended to embrace the Christian Religion—who, on his return to France, destroyed the Representative System—who, after seducing the Polish Legion into the Service of his pretended Republic, treacherously transferred it to St. Domingo, where it has perished to a Man, either by Disease or the Sword—and who, finally, as it were to fill the measure of his Arrogance, has *Dared* to attack what is most dear and useful to civilized Society, the FREEDOM of the PRESS and the FREEDOM of SPEECH, by proposing to restrict the *British Press*, and the Deliberations of the *British Senate*.—Such is the TYRANT We are called upon to oppose; and such is the Fate which awaits *ENGLAND*, should WE suffer him and his degraded *Slaves*, to pollute *OUR* Soil.

London: Printed for J. ASPERNE, Successor to Mr. SEWELL, at the Bible, Crown, and Constitution, No. 32, Cornhill, by J. and E. HODSON.

[PRICE 1d. or 6s. the 100, or 9d. per Dozen.]

39

1798
PRIVATE of YEOMANRY CAVALRY

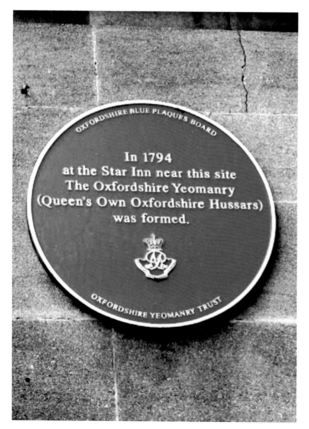

OXFORDSHIRE BLUE PLAQUES BOARD

In 1794
at the Star Inn near this site
The Oxfordshire Yeomanry
(Queen's Own Oxfordshire Hussars)
was formed.

OXFORDSHIRE YEOMANRY TRUST

The French Wars:
The Oxfordshire Fencible Cavalry
Fears of a French attack were so great at this critical period in British history that various additional forces were raised for home defence purposes. Oxfordshire's main contribution was in the form of volunteer Yeoman cavalry units, although a corresponding infantry unit known as the Oxford Loyal Volunteers was also formed as an adjunct to the Yeomen cavalrymen. In 1794, a meeting of 'Nobility, Gentry, Freeholders and Yeoman of the County' was held at the Star Inn in Oxford to discuss the raising of a troop of cavalry and, as a result, a regiment of Fencible Cavalry was raised under the command of Col. the Hon Thomas Parker. This was the beginning of what would later become the Oxfordshire Yeomanry. The sketch above depicts a Yeoman cavalryman of around 1798, while the photograph shows the blue plaque that marks the site of the Star Inn.

## The French Wars: The Mutiny of the Oxfordshire Militia

The need for extra forces during the protracted French wars meant that the Oxfordshire Militia – the lineal descendant of King Alfred's Fyrd – had been called up in 1778 to fulfil its traditional role as a home defence force. In June 1795, the regiment mutinied while billeted at East Blatchington in Sussex – the mutiny being caused because the men did not want to whiten their pigtails with flour, which they had to purchase using their own meagre pay. After order had been restored, four of the mutineers were flogged, while Pte Edward Cooke of Witney and Pte Henry Parish of Chipping Norton were shot by firing squad, as shown in the accompanying picture. On the day before he died, Pte Cooke wrote: 'I am going to die for what the regiment done. I am not afraid to meet death for I have done no harm to no person and that is a great comfort.'

*Drummer.*

## The French Wars: 1797–98 – The Years of Crisis

In February 1797, 1,500 Frenchmen landed at Fishguard as part of a triple-pronged attack involving simultaneous landings in Newcastle, Wales and Ireland. In that same critical year, sailors of the Royal Navy went on strike and demanded better pay and improved conditions. In the event, the landings in Ireland and Newcastle were thwarted by bad weather, while the 'Fishguard Invaders' became blind drunk, refused to obey their officers and surrendered to the Castlemartin Yeomanry. In the following year, a serious rebellion erupted in Ireland, but this was stamped out by the Irish Yeomanry, the decisive battle being fought at Vinegar Hill. The events at Fishguard and in Ireland demonstrated how effective the Yeomanry could be, and by 1798, Oxfordshire could boast four troops of Yeoman cavalrymen. *Above:* Yeomen shoot rebels at Vinegar Hill – sectarian atrocities were committed on both sides. *Left:* Rebels 'pike' a Protestant at Wexford.

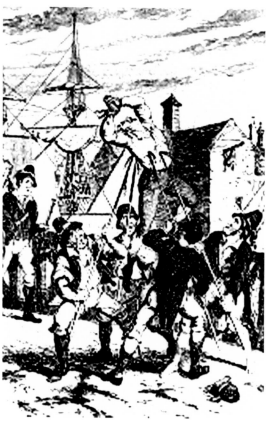

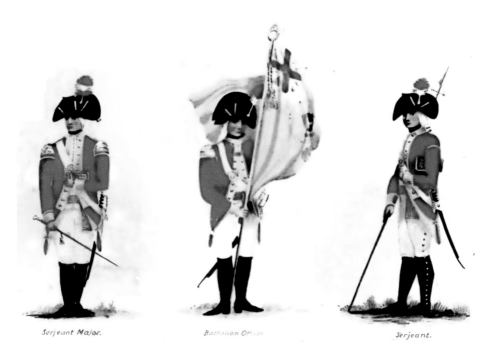

Serjeant Major.    Battalion Officer    Serjeant.

## The French Wars: The Oxfordshire Militia in Ireland

Shaken by the '98 Rebellion, the government sent English militia regiments to Ireland as a precaution against French incursions, and on 25 March 1799, *The Times* reported that 'the first division of the Oxfordshire Militia, quartered at Ipswich, marched to Colchester on their route to Gosport, there to embark for Ireland. The second and third divisions will march tomorrow and Tuesday for Portsmouth, where transports are prepared for their reception and conveyance'. The illustrations depict militia uniforms of the 1790s.

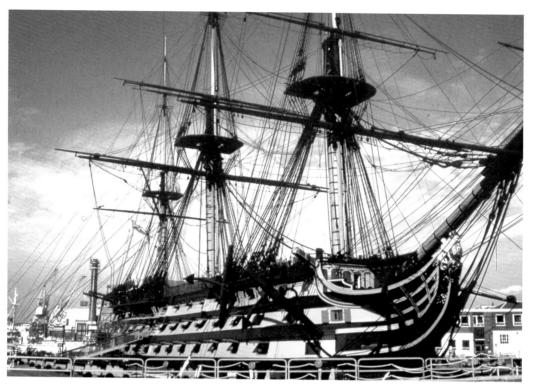

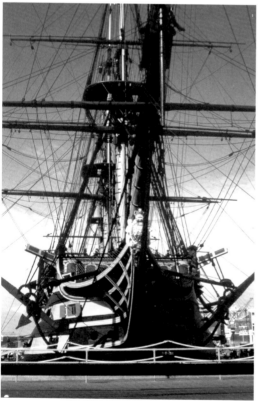

## The French Wars:
### Nelson's Victory at Trafalgar

On 21 October 1805, the British Navy destroyed a combined French and Spanish fleet off Cape Trafalgar, and the threat of a French invasion was lifted overnight. It is thought that around fifty Oxfordshire sailors participated in the battle, among them twenty-six-year-old Edward Druce of Witney, who served aboard Lord Nelson's flagship HMS *Victory* as an ordinary seaman. Other Oxfordshire sailors at Trafalgar included Royal Marine Private William Bartholemew (HMS *Africa*): Surgeon's Assistant Thomas Fisher (HMS *Revenge*); Able Seaman Henry Nash (HMS *Britannia*); Landsman Henry Styles (HMS *Victory*); Master's Mate William Sharp (HMS *Dreadnought*); Ordinary Seaman Thomas Hughes (HMS *Colossus*); Midshipman James Hanns (HMS *Neptune*); and Ordinary Seaman John Collier (HMS *Defiance*). The photographs show HMS *Victory*, now preserved in Portsmouth Dockyard. Timber from Wychwood Forest is said to have been used in its construction at Chatham in the 1750s.

## The French Wars: Sir John Moore and the Conversion to Light Infantry

The 43rd and 52nd regiments had been heavily involved in the war since its inception, the 43rd having seen active service in the West Indies, while the 52nd had served in India, Ceylon, Spain and Portugal. In 1803, it was decided that these two regiments would be reconstituted as specialised light infantry – the 43rd Regiment becoming the 43rd (Monmouthshire) Light Infantry, while the 52nd became the 52nd (Oxfordshire) Light Infantry. In July 1803, the first battalion of the 52nd Light Infantry was sent to Shorncliffe Camp, Kent, for special training under the direction of Sir John Moore. Here, they joined the 95th Rifles and 14th Light Dragoons to form the newly created Light Brigade – an elite force that would be ideal for expeditionary work, skirmishing and similar tasks. In January 1804, the 43rd Light Infantry, which had been stationed in the Channel Islands for the previous three years, was sent to Shorncliffe to join the 52nd for light infantry training. *Above:* Maj.-Gen. Sir John Moore (1761–1809), who had been colonel of the 52nd since 1801, was the son of a Glaswegian doctor. He served with distinction in America, the West Indies, Ireland and Holland, and became a brigadier at the age of thirty-four and a major-general by the time he was thirty-six. He was, in many ways, a radical idealist who would not have been out of place in Cromwell's Army. 'Towards corruption and injustice,' wrote Sir Arthur Bryant, 'he was merciless'; 'soldiers are flogged for drunkenness,' he once observed, 'I could not look them in the face if I was not to punish it equally in officers'. He treated his men as rational human beings capable of constant self-improvement – his ideal being a force of 'thinking soldiers' who knew what they had to do, and could adapt to constantly changing circumstances on the battlefield. *Below:* the bugle horn badge of the Light Infantry; the very obvious shamrock above the horn is significant in view of the large number of Irishmen who were serving in the Army at that time.

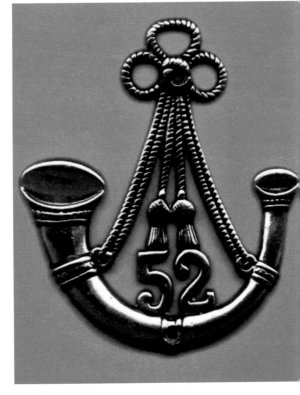

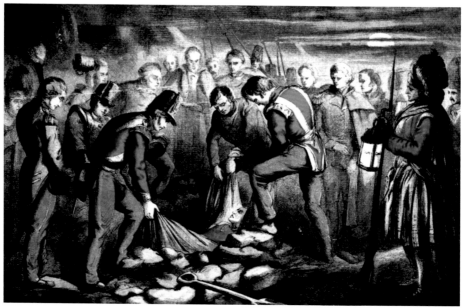

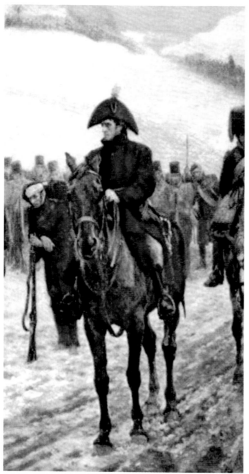

## The French Wars: 'We Buried Him Darkly at Dead of Night' – The Death of Sir John More at Corunna

Having taken part in a successful expedition to Denmark in the previous year, the 43rd and 52nd were sent to the Iberian Peninsula, where the Spanish had risen against the French. Led by Sir John Moore, the British expeditionary force was so successful that Napoleon prepared a counterattack. In danger of being surrounded and destroyed in Northern Spain, Moore began the retreat to Corunna on Christmas Day 1808. The Light Brigade, consisting of one battalion of the 43rd, one of the 52nd, and one of the 95th Rifles, formed the rearguard of the retreating Army and, as such, they endured appalling conditions in severe winter weather and mountainous terrain, as shown on the left. The exhausted Army staggered into the port of Corunna in January 1809, and the 14,500 survivors were rescued by the Navy. To secure a safe embarkation, Moore fought a rearguard action at Corunna, which resulted in his own death, as shown in the upper illustration.

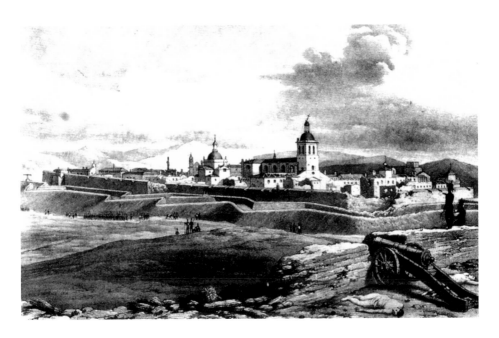

### The French Wars: The Storming of Ciudad Rodrigo

The first battalions of the 43rd and 52nd returned to Portugal in May 1809, and they played a leading part in Wellington's Peninsular Campaign. Early in 1812, Wellington stormed Ciudad Rodrigo (*above*), one of two fortified towns in French hands that covered the Spanish frontier. The attack was mounted from the outlying convents of Santa Cruz and San Francisco (*below*), which had been captured a few days earlier. Having entered the fortress, the soldiers sacked the town – their first target being the wine stores, which they rapidly emptied.

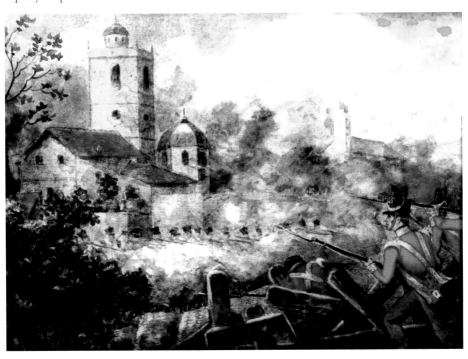

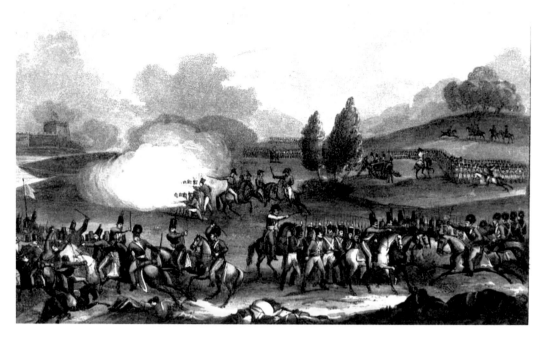

## The French Wars: 'To the Gates of Hell' – The Storming of Badajoz

In April 1812, Wellington attacked the fortress town of Badajoz. The siege and assault of Badajoz was the most costly action in the Peninsula War, 5,000 men being lost during the siege, while another 2,500 casualties were incurred during the final attack – 808 being members of the 43rd and 52nd. The upper picture is entitled *The Defeat of a French Division before Badajoz*, while the lower view depicts the storming of the breached walls, which the artist has depicted as the Gates of Hell.

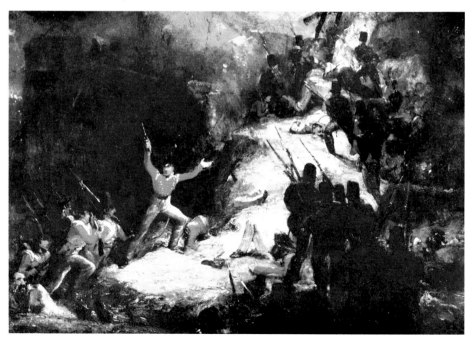

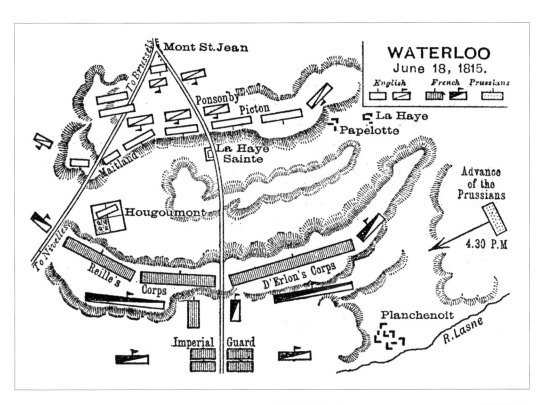

**WATERLOO**
June 18, 1815.

English    French    Prussians

Mont St. Jean
To Brussels
Ponsonby
Picton
La Haye
Papelotte
La Haye Sainte
Maitland
Hougoumont
To Nivelles
Reille's Corps
D'Erlon's Corps
Advance of the Prussians
4.30 P.M
Planchenoit
R. Lasne
Imperial Guard

## The French Wars:
## The 52nd at Waterloo

Napoleon abdicated in 1814, and the former French emperor was sent into exile on the island of Elba. However, he escaped in March 1815, and, having assembled an army of 130,000 men, he attacked the British and Prussian armies in Belgium. The Prussians, under Marshal Blücher, were severely mauled at Ligney on 16 June, but on 18 June the 'thin red line' of Wellington's Army repulsed Napoleon's veterans, and drove them from the battlefield as Blücher's Prussians were advancing from the west. The accompanying map shows the position of the armies at the start of the battle; the 52nd, originally deployed on the right of the allied line, later moved towards Hougoumont farm, from where they launched a furious charge against the enemy flank, just as the French were wavering. The lower picture shows the charge of the 52nd, led by Sir John Colborne. Napoleon surrendered to the British after the battle, which marked the end of the Napoleonic Wars.

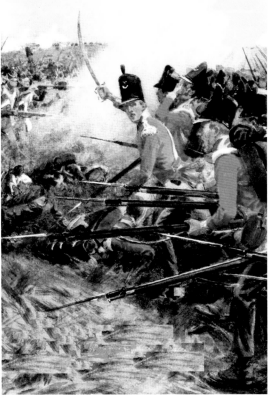

49

## The French Wars: An Oxfordshire Soldier at Waterloo

Several Oxfordshire soldiers fought at Waterloo, including Patrick Moulder of Witney, a member of the 15th Hussars, who had participated in the battles of Corunna, Vittoria, the Pyrenees, Orthes and Toulouse, before taking part in the Battle of Waterloo. In later years, Patrick Moulder, who was landlord of the Cross Keys Inn (*above*), became RSM of the Oxfordshire Yeomanry Cavalry. Sadly, in December 1838, RSM Moulder removed a pistol from the Yeomanry storeroom and shot himself; his servant found him with 'his head shot to atoms'. The inquest revealed that the deceased had been suffering from 'a disease of the heart which ... depressed the spirit'. Notwithstanding the manner of his death, RSM Moulder was buried with full military honours in the churchyard of Witney parish church on 18 December 1838, and over 3,000 people gathered to pay their respects to this Waterloo veteran. *Left:* Patrick Moulder's grave.

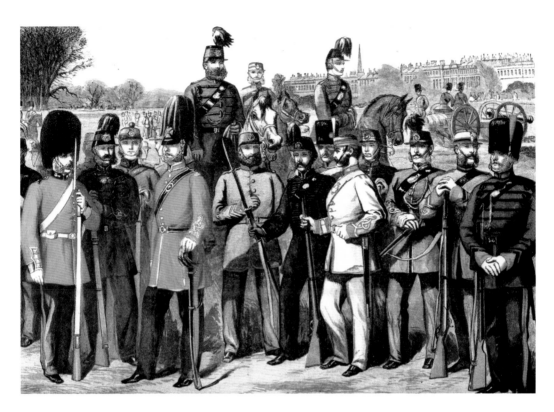

## Formation of the Oxfordshire Rifle Volunteer Corps

Fears of French aggression during the mid-nineteenth century underlined the need for additional volunteer forces, and in May 1859, the Lord Lieutenants of Counties were authorised to form volunteer corps. Over the next few months, around 170,000 volunteers were enrolled, and by the early months of 1860, four companies of rifle volunteers had been formed within the University of Oxford. These were soon merged into one unit, which was known initially as 'The 1st University of Oxford Rifle Volunteer Corps', but later became the 1st (Oxford University) Battalion. Meanwhile, other units were being established in towns such as Woodstock, Banbury and Witney, and these units were subsequently reorganised into the 2nd Oxfordshire Volunteer Battalion. *Above:* A group of volunteers from the London area; there was considerable variety of uniforms, although most Rifle Volunteer units adopted grey tunics. *Right:* A typical Rifle Volunteer shako of the early 1860s.

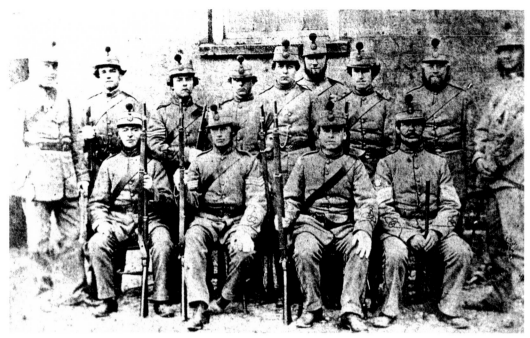

## The 5th Oxfordshire Volunteer Rifle Corps

*Above:* Members of the 5th Oxfordshire Rifle Volunteer Corps, photographed at Witney during the early 1860s. The 5th ORVC later became the Witney Company of the 2nd Oxfordshire Volunteer Battalion, which, in turn, became part of the 4th Battalion, Oxfordshire & Buckinghamshire Light Infantry. *Left:* William Seely, a Witney auctioneer, was a founder member of the 5th Oxfordshire Rifle Volunteer Corps. This photograph was taken around 1862, when William was about thirty years of age. In the early part of 1860, the government recommended standardised uniforms for the volunteer forces, the specifications for rifle volunteers being brownish-grey tunics, trousers and 'cloaks' with French-style shako caps '3¼ inches high in front, and 4½ inches at the back'. Thus attired, the grey-coated Oxfordshire volunteer riflemen of the early 1860s looked not too dissimilar to the Confederate soldiers who would shortly be fighting in the American Civil War. *Inset:* An Oxfordshire Rifle Volunteers shako badge, *c.* 1862.

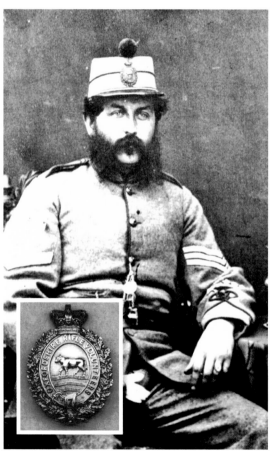

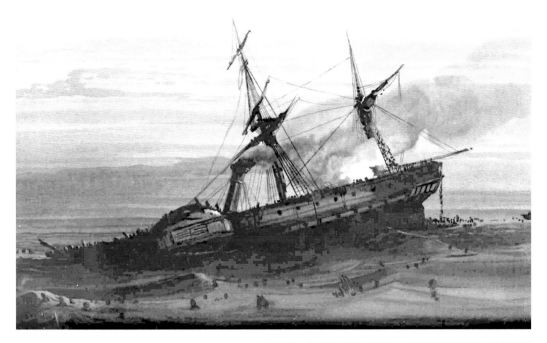

### 'Women & Children First' –
### The Loss of the *Birkenhead*

In 1851, the 43rd Light Infantry was sent to South Africa, where European settlers had provoked the African tribes into a series of native wars, which are generally known as the Cape Frontier Wars. In the following year, further drafts were despatched to South Africa, forty-one members of the 43rd being sent to the Cape aboard Her Majesty's steamer *Birkenhead*. Tragically, in the early hours of 26 February 1852, the *Birkenhead* struck a reef about 3 miles from the coast of South Africa at the aptly named Danger Point. The forward compartments immediately flooded, and the captain ordered the men to assemble on deck, while the women and children were helped into the boats; this was the first time that the order 'women and children first' was given. Over 440 men were drowned, including Henry Tucker of Oxford and William Debank of Witney; there were 193 survivors, including John Woodwards of Oxford.

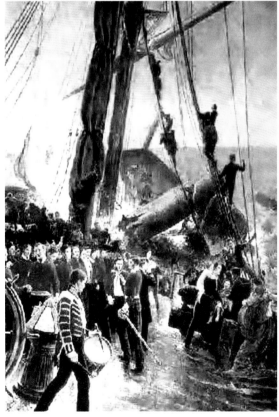

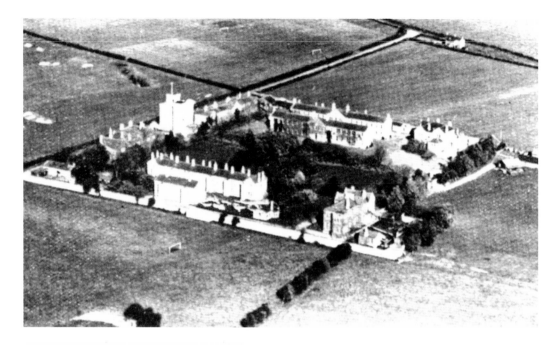

## The Cardwell Reforms

In 1868, Edward Cardwell (1813–86) was asked to modernise the Army, and the resulting Cardwell Reforms were far-reaching. The purchase of commissions was abolished and a twelve-year short-service system was introduced, whereby soldiers would serve part of their time with the colours and part with the reserve. Training and equipment were improved, and the militia and volunteers were brought into closer association with the regular Army. In connection with the reforms, a network of regimental depots was established, one of these being Cowley Barracks, which was built in what was then open countryside to the south-east of Oxford. Despite protests from Oxford University, construction of the barracks proceeded apace between 1874 and 1876, with most of the building work being carried out by Messrs Downs & Co. of Southwark at a contract price of £45,000. The upper view shows the barracks from the air, while the view on the left shows 'The Keep'.

**The Opening of Cowley Barracks**

Cowley Barracks was opened on 7 June 1876, the first units to occupy the site being the 52nd (Oxfordshire) Light Infantry and the 85th (Bucks Volunteers) Regiment. The upper picture provides another view of the tall, castle-like building known as 'The Keep'. This distinctive structure incorporated four full storeys, together with two somewhat taller stair towers at the north-western and south-eastern corners of the building. The medieval theme was further underlined by the provision of crenellations around the parapet of the main block and on top of the towers. The plan shows the layout of the depot, which provided a range of accommodation, including offices, mess rooms, stores, an armoury, married quarters, a guard room, cookhouse and stables, as well as a hospital. There were, in addition, two typical Victorian barrack blocks for the rank-and-file, and these were known as Moore Block and Napier Block.

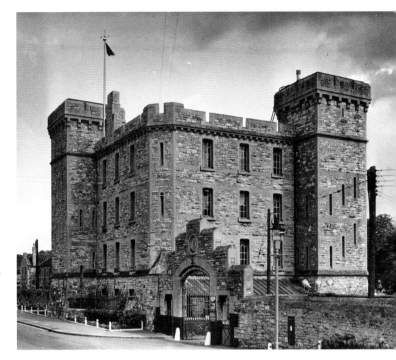

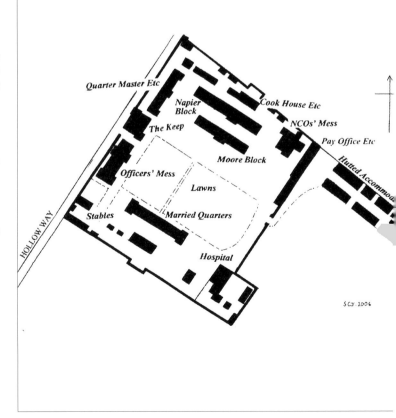

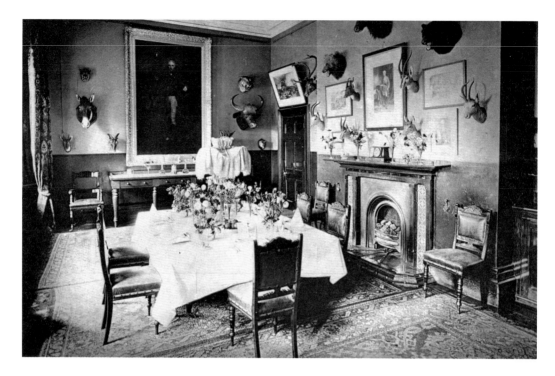

## Cowley Barracks: The Officers' Mess

The Officers' Mess contained a number of different rooms, the internal layout being not unlike that of a Victorian country house. On entering the building, one walked into a hall. A door at one end gave access to the toilets while, to the right, there were two anterooms, together with the mess itself. The upper picture shows the Officers' Mess room in 1904; a large picture of Sir John Moore can be seen on the far wall. *Below:* Horse-drawn transportation in 1904.

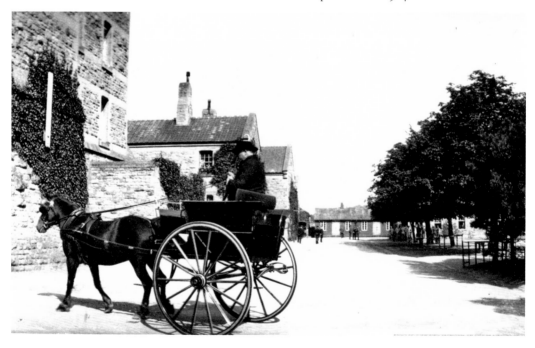

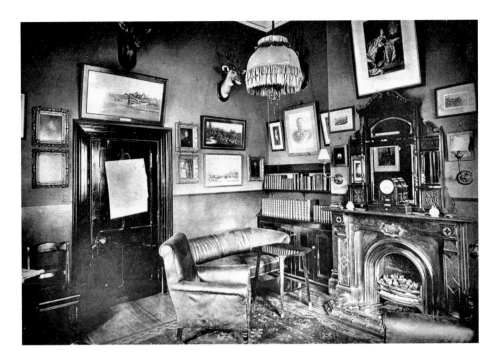

## Cowley Barracks: The Officers' Mess

*Above:* One of the anterooms, which were used as sitting room by off-duty officers. Col. Robin Evelegh recalled that, in his grandfather's day, around 1900, the Officers' Mess building contained private accommodation for the Commanding Officer and his family – the CO's domestic quarters being situated at the south end of the building. Other rooms served as residential apartments for the officers of the depot, while further accommodation was provided for mess servants on the upper floors. *Below:* Cowley Barracks in winter.

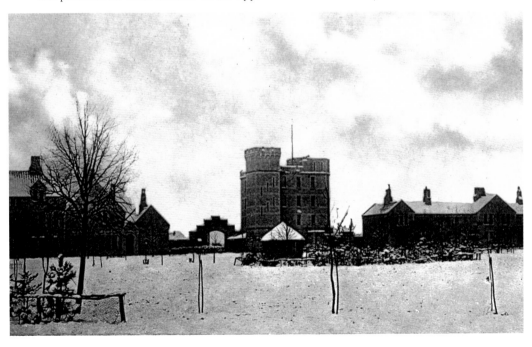

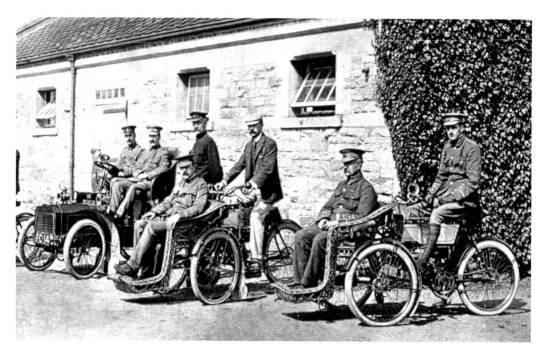

## Cowley Barracks: The Officers' Motors

*Above:* Some of the officers' motors in 1904. The facilities at Cowley (*below*) were rundown during the 1960s, and the two barrack blocks were sold to GPO Telephones in 1965, although the Officers' Mess remained in use as a Royal Green Jackets regimental office until 1968. The Keep was, unfortunately, demolished, but the barracks blocks are still extant, as shown in this 2007 colour view of Moore Block. The neighbouring Officers' Mess building is now part of Oxford Brookes University.

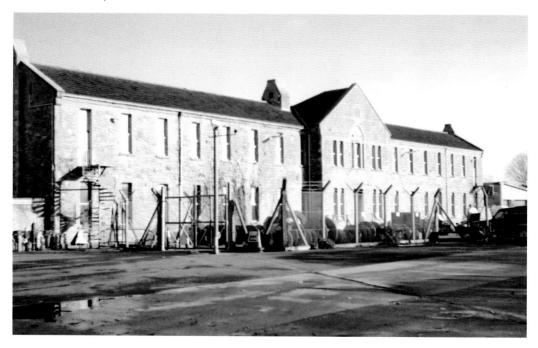

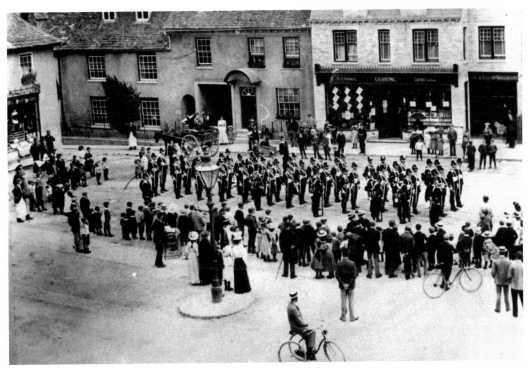

## Change of Titles:
### The Oxfordshire Light Infantry

Although the 85th Regiment had moved to
Oxfordshire in 1876, it was later decided that
the 43rd (Monmouthshire) Light Infantry would
be combined with the 52nd (Oxfordshire) Light
Infantry to form the 1st and 2nd Battalions of
the Oxfordshire Light Infantry. These two
regiments had been associated with each other
for many years, both having formed part of
Sir John Moore's Light Division. Accordingly, in
July 1881, the 43rd was moved from Shrewsbury
to Oxford, while in the following September,
the 85th Depot Company left Cowley Barracks
to take the place of the 43rd Light Infantry at
Shrewsbury. The colour picture shows a member
of the Oxfordshire Light Infantry at the end of
the Victorian period, while the sepia photograph
provides a glimpse of the 2nd Volunteer
Battalion parading in Witney Market Square,
c. 1890. The Volunteer Battalions wore red tunics
with white facings, their uniforms being very
similar to those of the regular battalions.

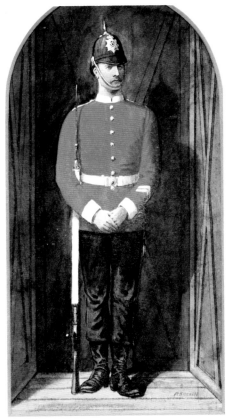

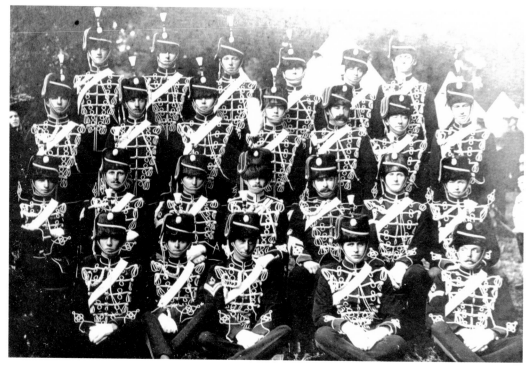

## Change of Titles: The Queen's Own Oxfordshire Hussars

In a parallel development, the Queen's Own Oxfordshire Yeomanry Cavalry was retitled 'The Queen's Own Oxfordshire Hussars' in 1881. As a corollary of this change of title, the regiment had, between 1856 and 1863, adopted Hussar-style uniforms. At the end of the Victorian period, the full-dress uniform of the Queen's Own Oxfordshire Hussars included a black tunic with elaborate silver braiding and mantua purple facings. The trousers were also mantua purple, with a silver stripe on each leg and additional silver braid above each knee. The black fur busby was adorned with a purple busby bag, a tall plume and a silver chinstrap. The highly polished Hessian boots had silver edging on the top with a purple boss and pink heels. The upper picture shows a group of Oxfordshire Yeoman in 1911, while the photograph on the left depicts Trooper Wesley Miles in his full-dress uniform.

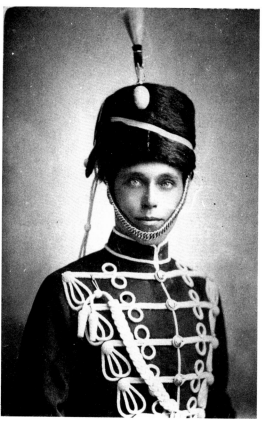

### The Boer War: The Outbreak of Hostilities

War broke out between Britain and the Boer republics on 12 October 1899. Britain had few regular troops in South Africa, and most of these became trapped in the besieged townships of Mafeking, Kimberley and Lady Smith. A series of military disasters at the start of the war evoked a wave of patriotism, not only in Britain but throughout the Empire, and reinforcements were soon en route from Britain, Canada, Australia and New Zealand – the Oxfordshire Light Infantry being among the first units to be sent to the conflict zone. The upper picture shows members of the 1st Battalion Oxfordshire Light Infantry in the ratlines of the screw steamer *Gaika* as she approaches Cape Town in January 1900, while the lower photograph shows a member of the regiment in characteristic Boer War uniform – the familiar Light Infantry bugle horn badge being displayed on a red, diamond-shaped badge on his helmet.

In the meantime, the Imperial Yeomanry had been established in December 1899 to facilitate the employment of Yeomanry volunteers in South Africa. Lord Valentia of the Queen's Own Oxfordshire Hussars and Lord Chesham of the Royal Bucks Hussars played prominent parts in the organisation of this new force.

It was envisaged that each county would furnish one company of around 120 men, but so many men volunteered that most counties provided at least two companies. Oxfordshire, for instance, contributed the 40th and 59th companies, while the more populous county of Buckinghamshire provided the 37th, 38th, 56th and 57th companies. The companies were formed into battalions, many of which were geographically based – the 13th Battalion being a mainly Irish unit that included the 45th Dublin (or 'Irish Hunt') Company, while the Oxfordshire, Buckinghamshire and Berkshire companies were formed into the 10th and 15th Battalions.

*Inset:* A cloth badge depicting the Oxfordshire Light Infantry bugle horn within a red diamond, as worn during the Boer War. A very similar badge was worn on slouch hats during the Second World War.

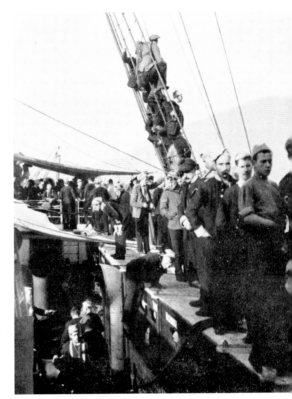

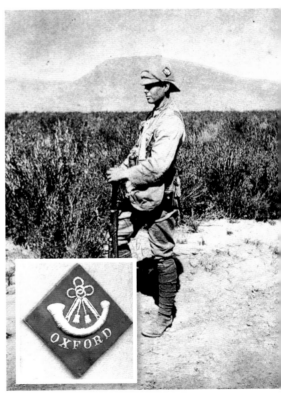

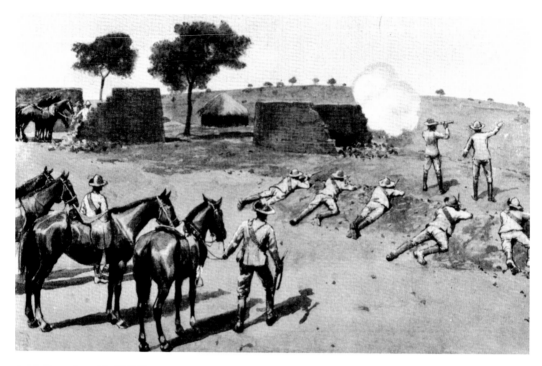

The Boer War: Frank Smitheman and the Relief of Mafeking

Kimberley was relieved in February 1900, and Lord Roberts occupied Bloemfontein on 13 March, while in May the British annexed the Orange Free State. On 1 September, Britain annexed the Boer republic of the Transvaal. *Above:* Mafeking, which had been under siege since the start of the war, was relieved on 18 May 1900. The picture shows Baden Powell (with telescope) observing the enemy. Although the regular Oxfordshire forces had no direct involvement in the Relief of Mafeking, an Oxfordshire man, Capt. Frank Smitheman, DSO of the Rhodesian Regiment (*left*), played an important part in the siege, and helped over 1,500 African women and children to escape through the Boer lines. Capt. Smitheman, who had been born at Witney in 1872, the son of the local stationmaster, was an African explorer and big game hunter, activities that clearly helped him to carry out his duties as Gen. Plummer's intelligence officer.

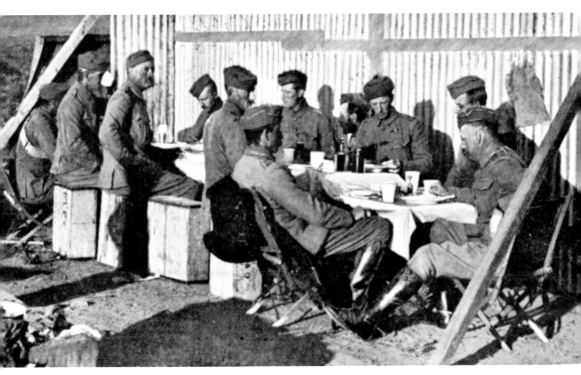

## The Boer War:
## The Imperial Yeomanry at Lindley

On Sunday 27 May 1900, the 13th Battalion Imperial Yeomanry, comprising about 500 predominantly Irish volunteers, led by Lt-Col. Basil Spragge, was ambushed by around 2,000 Boers at Lindley, about 45 miles east of Kroonstad. Having made a stand on a nearby kopje, Col. Spragge's beleaguered force surrendered on 31 May, and over 300 Yeomen were taken prisoner. The sepia picture shows Col. Spragge and his officers after capture. On 31 May 1900, the 40th (Oxfordshire) Company formed part of the 10th Battalion Imperial Yeomanry, which, together with the 3rd and 5th Battalions, made a forced march to Lindley in an abortive attempt to rescue the Irish Yeomen. The colour photograph, taken by Col. Tim May in 2011, shows the Yeomanry memorial at Lindley, bearing the names of those who lost their lives, including Thomas Brooke Miller of Shotover and Edward Erskine Chetwoode of Oxford, both of whom had served with Col. Spragge's ill-fated 13th Battalion.

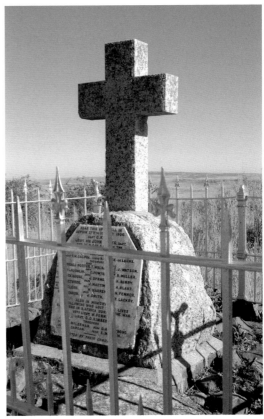

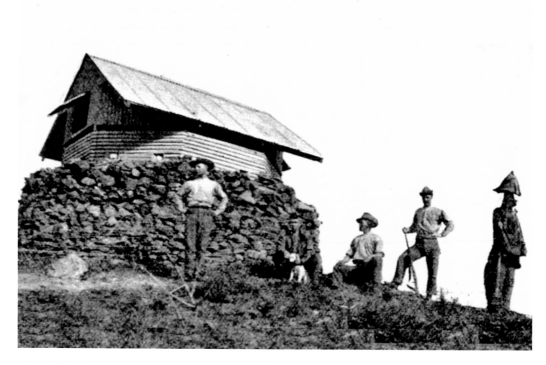

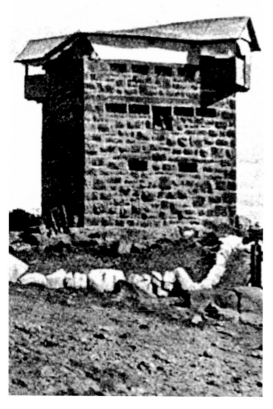

## The Boer War:
### Blockhouses and Guerrilla Warfare

Although the Boers had been defeated
in open battle, Kitchener's peace terms
were rejected in February 1901, and,
guerrilla warfare having resumed, lines
of blockhouses were constructed across
the veldt to impede the movement of the
mounted Boer commandos. Most of the
later blockhouses were of corrugated iron
construction, about 8,000 blockhouses
and 3,700 miles of wire fencing being
employed, while the blockhouses required
a garrison of around 50,000 troops. The
upper picture shows members of the
Oxfordshire Light Infantry beside their
corrugated iron blockhouse, and the
lower view depicts a standard, two-storey
masonry blockhouse. In addition to the
blockhouse system, the British initiated a
series of great 'drives' across open country
in an attempt to round up the remaining
Boers and confiscate their farms and
livestock. Both sides, however, were tired
of the war, and after the lengthy peace
negotiations had run their course, the
Treaty of Vereeniging was signed on
31 May 1902.

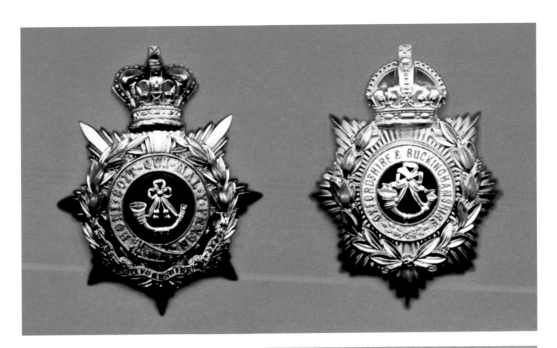

## The Haldane Army Reforms and the Oxfordshire & Buckinghamshire Light Infantry

British reverses at the start of the Boer War underlined the need for further reform of the nation's armed forces, and in this context the changes initiated by Richard Haldane, the Minister of State for War in Herbert Asquith's Liberal government, were designed to increase efficiency by creating a small, regular Army that could be rushed to the Continent to face an enemy that was assumed to be Germany. The militia regiments were formed into the Special Reserves, while the Yeomanry and Volunteers became the Territorial Force – the Oxfordshire Militia became the 3rd Battalion, while the 2nd Volunteer Battalion became the 4th Battalion. These changes had important ramifications, insofar as the former Buckinghamshire Rifle Volunteers became a reserve battalion of the regiment, which was retitled the Oxfordshire & Buckinghamshire Light Infantry in 1908. The accompanying photographs show a pre-1908 Oxfordshire Light Infantry home service helmet, and two helmet plates.

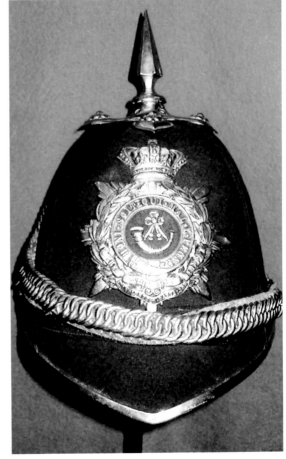

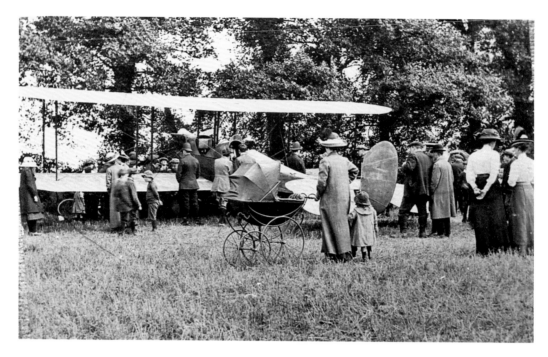

## The Beginnings of Military Aviation in Oxfordshire

On 14 June 1911, a Farnham III pusher biplane landed on Port Meadow, thereby becoming the first aeroplane to land in Oxfordshire. Other aircraft landed as part of a cross-country exercise in the following August and, thereafter, Port Meadow became a recognised landing ground. The pictures show a Royal Flying Corps BE2a that landed at Witney on 1 October 1913. Like Port Meadow, Witney would become the site of a military aerodrome; few of the people in these photographs would have seen an aeroplane before!

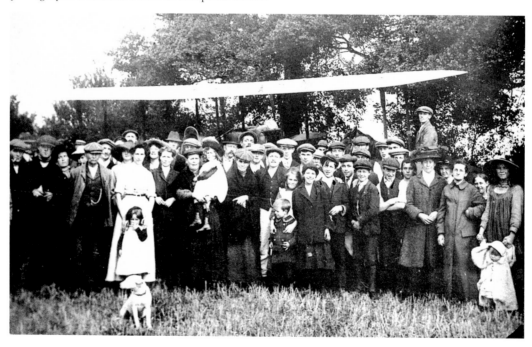

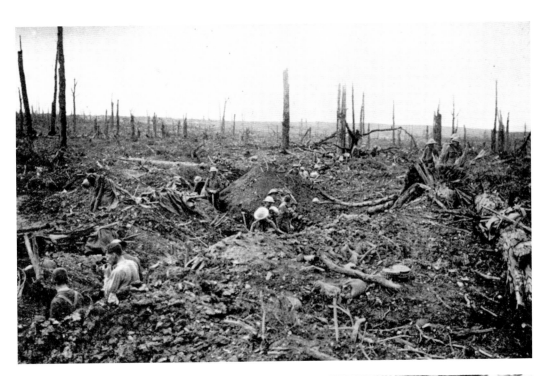

## The First World War:
## The Start of the Conflict

The First World War broke out on
4 August 1914, following the assassination
of Austrian Archduke Franz Ferdinand
at Sarajevo on 28 June. Many local
men served in the Oxfordshire &
Buckinghamshire Light Infantry, which
was sent to France at the start of the
conflict, together with the county's
other regiment, the Queen's Own
Oxfordshire Hussars. The Oxfordshire &
Buckinghamshire Light Infantry comprised
five battalions at the commencement of
the war, but the demand for manpower
was so enormous that the regiment was
expanded to seventeen battalions. The
regiment was involved in numerous
actions on the Western Front, including
the battles of Mons, Ypres, Loos, the
Somme, Arras, Cambrai and Passchendaele.
In addition, the much-expanded regiment
also saw action in Mesopotamia, the
Balkans and in Italy. The illustrations
show a communications trench under
construction on the Western Front, and
Capt. C. A. F. Fowke at the entrance to
an officers' dugout known as 'The
Guards Club'.

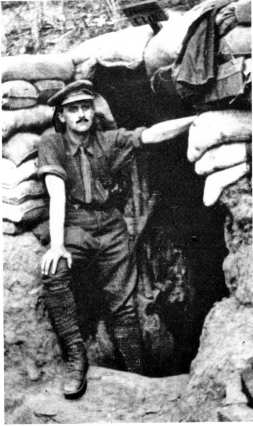

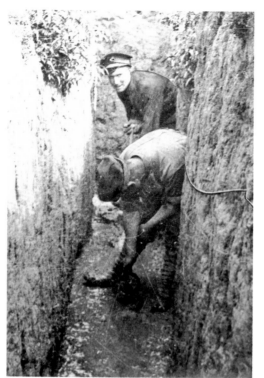

## The First World War: Stalemate on the Western Front

Although the Germans had some initial success, their plans were thwarted by the Franco-British armies at the Battle of the Marne. Having failed to knock France out of the war in the first few weeks of the conflict, the Germans were forced to dig-in along the Western Front. The opposing lines of trenches extended from the Channel to the Swiss border, and they were destined to remain in more or less the same static positions for the next four years. The upper picture shows Sergeant Bayley and another member of the 2nd Battalion Oxfordshire & Buckinghamshire Light Infantry cleaning up a communication trench known as the 'Birmingham Arcade' in August 1915. The lower view shows a group of Queen's Own Oxfordshire Hussars during the first weeks of the war; seventeen-year-old Trooper Albert Horne of Witney (second from left) was killed in action on 16 November 1914.

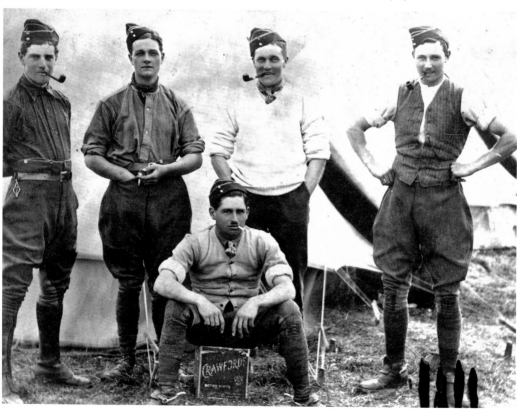

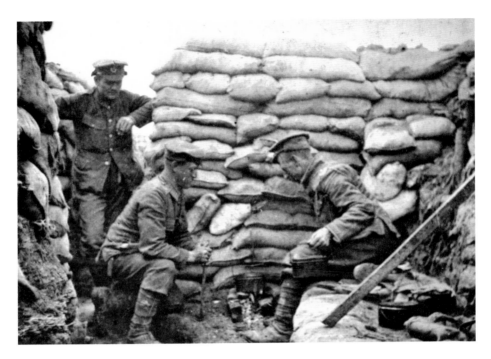

## The First World War: The Local Regiments on the Western Front

*Above:* Members of the Oxfordshire & Buckinghamshire Light Infantry having a cup of tea in their trench on the Western Front on 26 August 1915. This photograph was taken by Capt. Fowke, who was a descendant of Lt-Col. Thomas Fowke, who had raised the 43rd in 1741. *Below:* Five mounted Oxfordshire Yeomen, possibly in France. The demand for infantry was so great that over 400 members of the QOOH were transferred to the Oxfordshire & Buckinghamshire Light Infantry in September 1916.

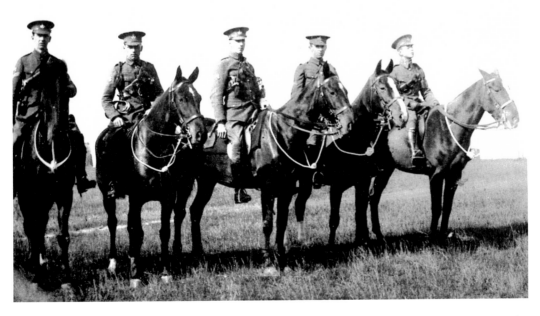

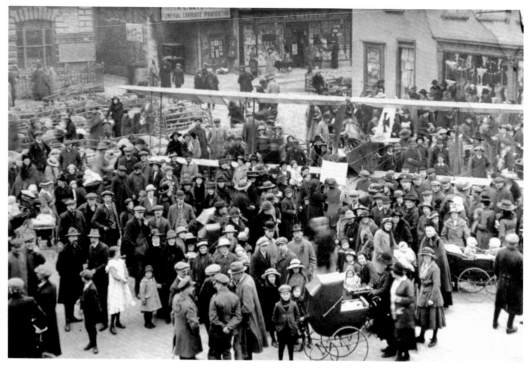

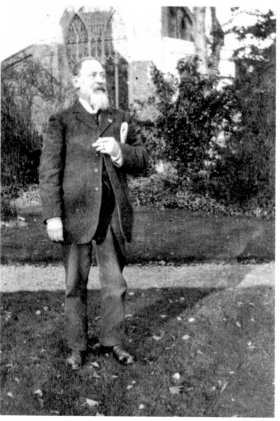

The First World War:
On the Home Front in Witney
*Above:* Crowds swarm around a captured German aircraft in Witney's Market Square during War Bonds Week in March 1918. *Left:* Professor Sibenhaller, a Belgian refugee from Anvers, photographed outside Witney parish church in 1915. Professor Sibenhaller, who arrived in Witney during the early part of the war, was in his seventies, and became something of a local character. Phyllis Ransom recalled that 'he would talk about the war, and his adventures as a refugee, in mixed up English and French. He was called "Professor" and would draw pictures for me, comic ones of Kaiser Bill and the Crown Prince'. The Belgian refugees who came to Oxfordshire were women, children and old men. The women wore distinctive black dresses with long flowing veils, as though they were in perpetual mourning.

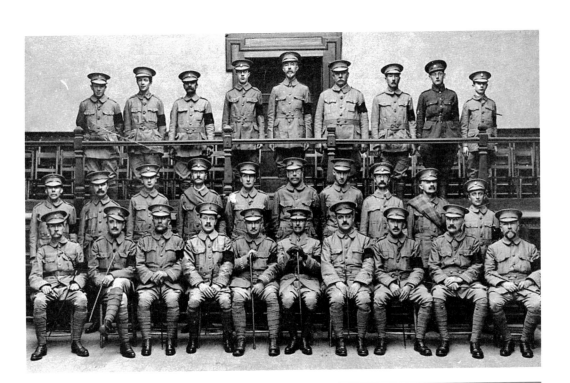

## The First World War:
## The Volunteer Training Corps

Following the outbreak of war in August 1914, a number of town guard or volunteer units were spontaneously formed throughout the UK. These became the nucleus of the Volunteer Training Corps, and in November 1914, the Central Association of the Volunteer Training Corps was formally recognised by the War Office. The VTC units thereby became the First World War equivalent of the Home Guard although, at first, they did not carry arms. Members of the VTC wore greenish-grey uniforms and bright red armbands bearing the letters 'GR', which, according to a popular joke, stood for 'Grandpa's Army' or 'Government Rejects'! The sepia photograph shows members of the Witney VTC, probably in the Corn Exchange, while the cap badge and armband were worn by W. T. Ransom during the First World War.

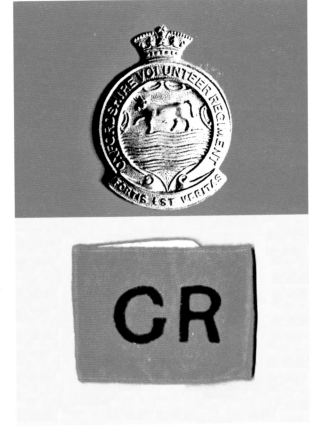

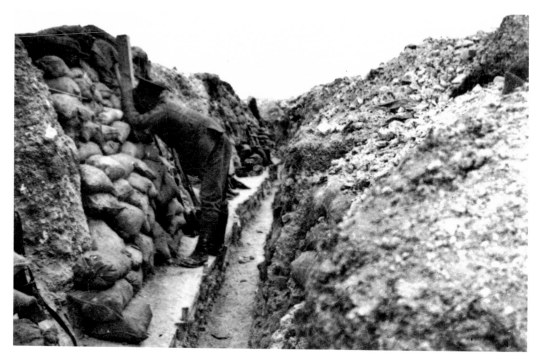

## The First World War: In the Trenches

*Above:* A view of the trenches at Vermelles in May 1915. An unidentified member of the Oxfordshire & Buckinghamshire Light Infantry is looking over the parapet with the aid of a trench periscope. *Below:* Another photograph taken by Capt. Fowke, showing a soldier 'writing home from a front-line trench at Givenchy' in August 1915.

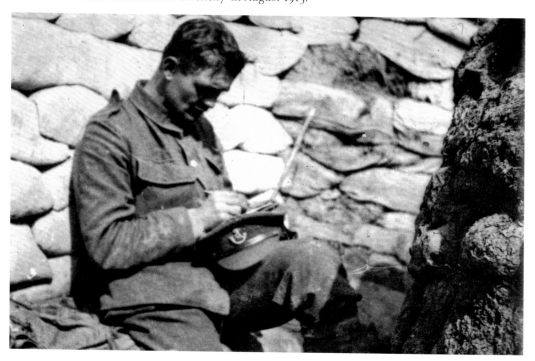

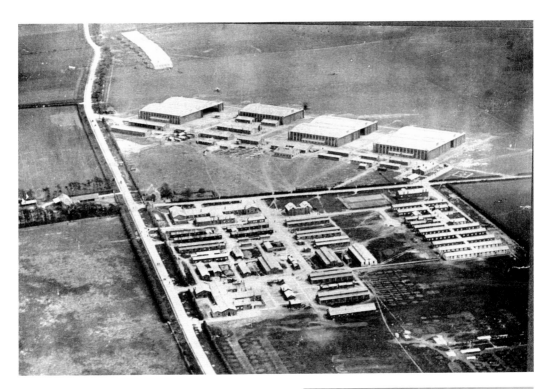

## The First World War:
## The Construction of Witney Aerodrome

*Above:* Witney Aerodrome was constructed
on requisitioned farmland at Downs Farm,
to the west of Witney. Much of the building
work was undertaken by German prisoners
of war and Portuguese labourers. The airfield
was opened in 1918, and the main aircraft
movements commenced in March 1918, when
Nos 8 and 24 Training Squadrons moved
from Netheravon. The airfield occupied two
sites, the seven Belfast Truss roof hangars
and grass-covered landing area being sited to
the east of the road to Curbridge, while the
domestic site was situated immediately to the
west. Additionally, a line of canvas-covered
Bessonneau hangars was erected to the east
of the main hangar complex. *Right:* Military
aviation was the responsibility of the Royal
Naval Air Service and the Royal Flying Corps
at the start of the First World War, but on
1 April 1918, the RNAS and the RFC were
amalgamated to form the Royal Air Force.
The newly created RAF was well represented
in Oxfordshire, with airfields at Port Meadow,
Witney, Bicester, Weston-on-the-Green
and Heyford.

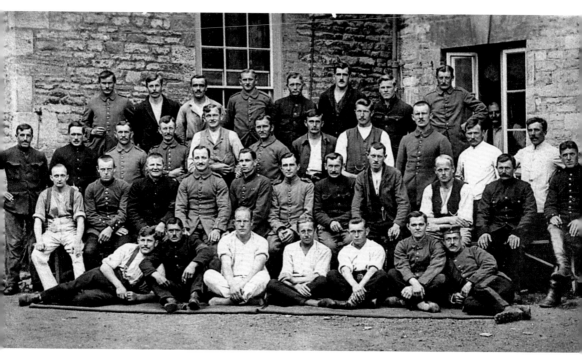

## The First World War: Ludendorff's Defeat and the End of the War

General Ludendorff staged a final German offensive in 1918, but his soldiers had lost their spirit, and entire divisions surrendered in scenes unprecedented in German military history. Austria capitulated on 4 November 1918, and an armistice with Turkey was announced on 1 November. The First World War came to an end with the surrender of Germany on 11 November 1918. The upper picture shows German prisoners of war at the Fleece Hotel in Witney, and the lower view shows them returning home from Witney station.

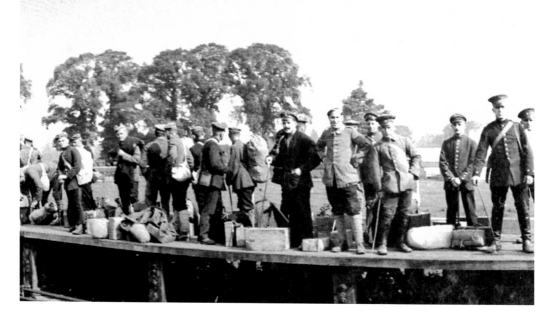

## The First World War: Memorials to the Fallen

The British Empire lost 1,115,597 men during the First World War, and this hitherto unprecedented loss resulted in an outpouring of public grief and the construction of war memorials in virtually every town, city and village in the land. *Above:* The 5,878 members of the Oxfordshire & Buckinghamshire Light Infantry who had lost their lives in the First World War were commemorated by a regimental war memorial, which was designed by Sir Edward Lutyens (1869–1944). When unveiled on 11 November 1923, the Portland stone obelisk was sited in what was then 'the corner of an orchard at the junction of the Henley and Cowley roads', although the area has now been thoroughly suburbanised. *Right:* The Oxford war memorial is situated in St Giles. It was designed by Thomas Rayson (1888–1976), in association with John Thorpe and Gilbert Gardner, and unveiled in 1921.

## The First World War: Memorials to the Fallen

*Above:* Thomas Rayson, who had been involved with the construction of Witney Aerodrome during the First World War, designed similar memorial crosses at Witney, Woodstock and Chester. The Witney war memorial was erected on Church Green, and dedicated on 19 September 1920. It is inscribed with 157 names, and a further thirty-five names were added after the Second World War. The town's War Memorial Committee had hoped to raise sufficient funds to construct a cottage hospital, but when the target figure was not reached the committee decided that the Church Leys would be purchased from the Church of England and adapted for use as a public park in memory of those who had died in the war. *Left:* Langford war memorial, which was unveiled in 1920, was inscribed with the names of nine men from the village who had given their lives in the First World War; three more names were added after the Second World War.

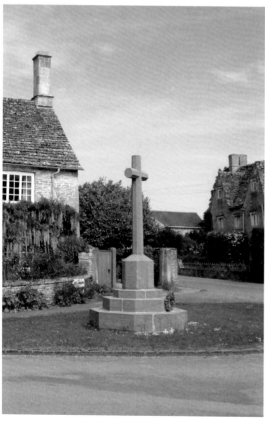

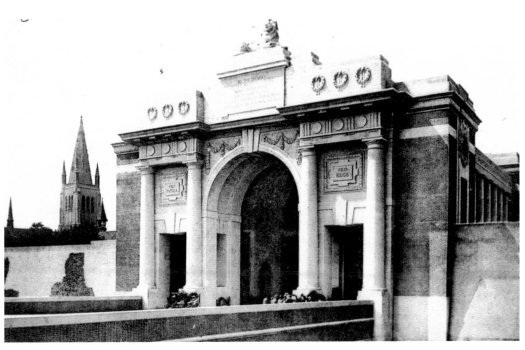

## The First World War: Memorials to the Fallen

The famous Menin Gate at Ypres, in Belgium, which was designed by Reginald Blomfield as a memorial to the 54,896 British and Commonwealth soldiers who died in the Ypres Salient and have no known grave. It is in the form of a triumphal arch, and stands on the site of the Antwerpenpoort Gate, which had been removed during the nineteenth century when about half of the town's encircling fortifications were removed as part of an urban redevelopment scheme.

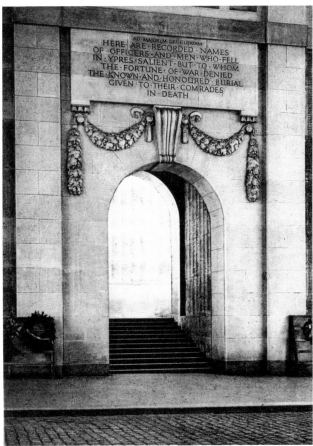

## The Rise of Fascism:
## Basque Children at Aston

Over 20,000 children were evacuated from the Basque Region of northern Spain after the bombing of Guernica by the German Condor Legion during the Spanish Civil War in 1937. About 4,000 were brought to England and relocated in around seventy Basque 'colonies', one of these having been established in a former children's home at Aston known as St Joseph's (now Westfield House). The Aston colony had been set up largely through the efforts of Patrick Early (1909–66), a director of Messrs Charles Early & Co., the well-known Witney blanket-making firm, who ran the local Aid for Spain committee. St Joseph's remained in use until October 1939, and during that time it relied upon the goodwill and support of local people such as Phyllis Ransom, the daughter of a Witney chemist, and Oxford undergraduates such as Cora Blyth (the mother of politician Michael Portillo), who was then a modern languages student at St Hilda's, and had volunteered to teach English to the Basque children at weekends. She later married Luis Gabriel Portillo (1907–93), a university lecturer who had fled from Spain in February 1939, and was helping in the Basque colonies as a teacher. The pictures show Phyllis Ransom with some of the Basque children at Aston. About 3,000 of the Basque children had been repatriated by the outbreak of war in 1939, although about 470 were still in the United Kingdom in July 1940. The Aston colony, which absorbed children from several other colonies when they were closed down, was itself closed around October 1939. The seven girls who still remained were then transferred to a council house in Schofield Avenue, Witney. It is thought that around 250 of the Basque refugees remained in the UK after the Second World War, having settled, found employment, married and had families.

## The Rise of Fascism:
## A Trip to the Third Reich

*Above:* A further view of Phyllis
Ransom with the Basque children at
Aston. Interestingly, Miss Ransom had
first-hand experience of fascism, having
visited the Third Reich with a party
from the National Union of Students to
see the Passion Play at Oberammergau.
They spent the rest of the holiday
touring Germany, and were shown
round a number of university cities
by German students wearing brown
or black uniforms. She recalled that
'towards the end of the holiday when
I was happily tracing on a wall map of
Europe the route we had been following',
a Brownshirt had casually pointed to
the Danzig Corridor on a map of Europe
and said 'the next war will start there
... five years later it happened'. *Right:*
A postcard acquired by Phyllis Ransom
during her trip to Nazi Germany. It
depicts giant Hitler Youth banners
hanging in an anti-Jewish exhibition.

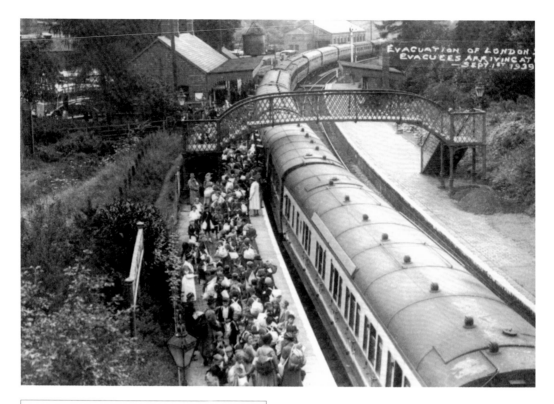

The handwriting on the photograph reads: *EVACUATION OF LONDON. EVACUEES ARRIVING AT ~Sept.1st 1939*

## GREAT WESTERN RAILWAY.
*(For the use of the Company's Servants only.)*

## LONDON DIVISION.

NOTICE OF

# ARRANGEMENTS IN CONNECTION WITH LONDON EVACUATION SCHEME (No. 2)
(TO OPERATE FOR FOUR DAYS)

ALSO

## Altered Working of Passenger Trains.
(TO OPERATE DURING THE EVACUATION PERIOD AND DAILY THEREAFTER
UNTIL INSTRUCTIONS ARE RECEIVED TO THE CONTRARY.)

When it is necessary to operate the arrangements shewn in this Notice all concerned will be advised by telegram as under :—

" EVAK "

The working to be brought into operation on the following day, beginning with the 2.30 a.m. Paddington (down) and the 4.38 a.m. Slough (Up). Empty trains to begin the programme to start at the times scheduled. RECEIPT OF THE TELEGRAM TO BE ACKNOWLEDGED AT ONCE AS UNDER :—

"WILLOW EVAK "

The special train arrangements in connection with the London Evacuation Scheme to remain in operation for FOUR DAYS. The programme of trains for ordinary passengers to be repeated daily until instructions are received to the contrary.

If a Saturday or Sunday should fall within this period the programme must be maintained subject to the modifications shewn herein. Trains shewn with note SUX will not run on Sundays.

The arrangements shewn in this Notice must not be circulated to more members of the staff than is necessary for the smooth working of the programme, and information, other than details of the ordinary train services, must not be circulated to the general public.

GENERAL INSTRUCTIONS.

For General Instructions to be observed in connection with the running of the Special Trains shewn herein, see the Company's Rule Book, dated 1933, and the General Appendix thereto, dated July, 1936.

ENGINEERING OCCUPATIONS.

SPEED RESTRICTIONS.
The Permanent and Temporary Speed Restrictions in operation must be strictly adhered to and the arrangements shewn herein are also subject to alteration and such other special instructions as appear in the Weekly Speed and Engineering Notice or Special Notices.

F. R. POTTER,
*Superintendent of the Line.*

August, 1939.

C. T. COX,
*Divisional Superintendent.*

The Second World War: The September 1913 London Evacuation Scheme
War was declared on Sunday 3 September 1939, following the German invasion of Poland. The Army was mobilised, and three battalions of the Oxfordshire & Buckinghamshire Light Infantry were sent to France. *Above:* Meanwhile, over 37,000 women and children were evacuated from London to Oxfordshire on the weekend of 1–4 September, special GWR trains being sent to Oxford, Witney, Chipping Norton and other designated 'reception stations'. The evacuation trains were formed of ten or twelve coaches, as shown in this picture of 'Train No. 158' alongside the down platform at Chipping Norton on 1 September 1939. *Left:* GWR Working Notice No. 24 issued in connection with the 1939 Evacuation Scheme. It contained ninety-two pages of timetables and instructions involving the provision of sixty-three trains per day between London and stations in the west of England, comprising fifty-eight that were scheduled to depart from Ealing Broadway, together with four from Acton and one from Paddington.

### The Second World War: Evacuation

One of those evacuated from London was twelve-year-old Stanley Edgar Jenkins (the author's uncle), who was billeted in Witney and presumed to have attended the Batt Church of England School. Having reached the age of fourteen, Stanley left Witney and moved to No. 8 Viola Avenue, Ashford, Middlesex, a semi-rural area that was considered to be safer than east London, which had been badly bombed during the Blitz. Stanley joined the Home Guard, while continuing his studies to become an engineer but, sadly, he was killed during an air raid on his home on 23 February 1944. He had been standing at his bedroom window and was caught by the blast, death being instantaneous; he was seventeen years old. *Above:* Stanley Edgar Jenkins (second from right) outside the rectory at Witney with his brother Mortimer Charles and mother Kathleen. *Right:* Stanley with his father, Charles William Jenkins.

### The Second World War: Escape from Dunkirk

The first few months of the war were so uneventful that people spoke derisively of 'The Phoney War'. But the Germans attacked in May 1940, and the British Army was evacuated from Europe via Dunkirk. Three battalions of the Oxfordshire & Buckinghamshire Light Infantry were involved, the 43rd and Bucks Battalions being part of the rearguard, although many survivors managed to escape in the 'little ships' – notably the cross-Channel steamer *Maid of Orleans,* shown above, and the destroyers *Worcester* and *Scimitar* (*inset*). The lower picture shows the *Royal Daffodil*.

M. V. 'ROYAL DAFFODIL'

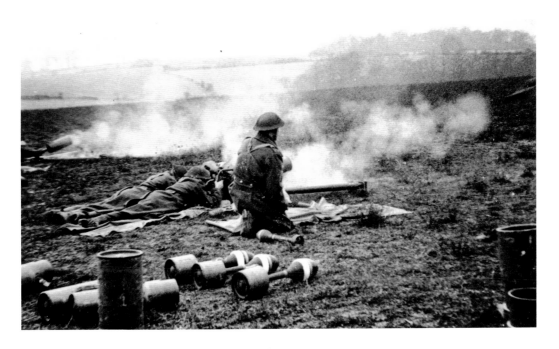

## The Second World War: The Home Guard

The Fall of France heralded the most serious phase of the war, and on 14 May 1940, able-bodied men aged seventeen or over were invited to join a home defence force to be known as 'The Local Defence Volunteers'. Thousands of men enrolled in the new force, which was soon renamed 'The Home Guard'. There were about 13,500 Oxfordshire Home Guardsmen, and they were organised into eleven battalions. The pictures show members of the 3rd Battalion training at Crawley (*above*) and on parade in Witney (*below*). *Inset:* A Home Guard lapel badge worn by a member of the 3rd Oxfordshire Battalion.

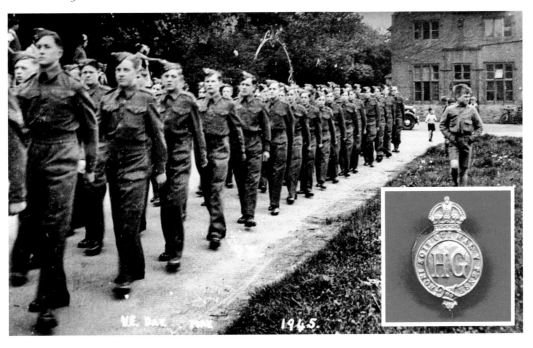

## The Second World War: Pillboxes and Stop Lines

It was recognised that in the event of an attempted German invasion, the British coastline was too long to defend. Internal 'stop lines' were therefore constructed, one of these being the GHQ Red Stop Line, which followed the Thames from Wiltshire to Reading. The upper view shows a standard Type 22 hexagonal pillbox on the Red Stop Line near Tadpole Bridge, while the lower picture shows a Type 25 Norcon-pattern pillbox at Witney; both photographs were taken in 2013.

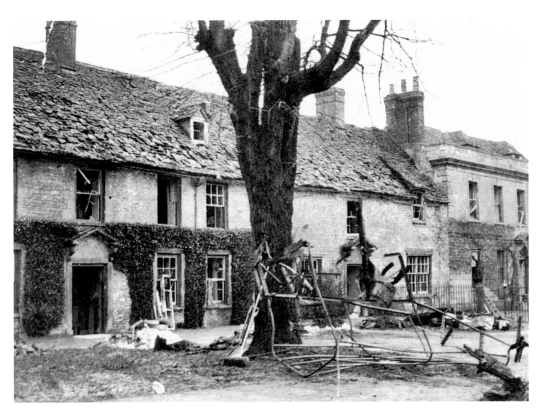

## The Second World War:
## Air Raids on Oxfordshire

The county was bombed several times. On 16 August 1940, for example, a daylight raider destroyed no fewer than forty-six Airspeed Oxford trainers on the ground at RAF Brize Norton. On the same day, the Germans dropped ten bombs and machine-gunned airfield construction workers at RAF Stanton Harcourt, while Stanton Harcourt was bombed again on 2/3 October 1940 and 4/5 May 1941. On the night of 21 November, Witney was hit by two high-explosive bombs; one landed on Church Green, the other exploded behind the Eagle Brewery. The pictures show bomb-damaged houses on the east side of Church Green. Over 200 properties were damaged by the blast. Millie Dore (*née* Harris) recalled that the town was in 'a great mess, with stone slates all over the road and windows smashed everywhere'. There was a bread shop, she remembered, 'and all the loaves had been blown into the street!'

**The Second World War:**
**The Women's Land Army**
As the war effort got into
full stride, factories such as
the Witney blanket mills and
Cowley car plants were adapted
for wartime production, while
the Women's Land Army was
created to provide additional
labour for agricultural work.
The upper view shows members
of the Land Army at work in
woodland near Charlbury; they
may be members of the Timber
Corps, which was started in 1942
as a separate branch of the Land
Army. *Left:* A photograph of
Joyce Landford (*née* Hunt),
who worked at Rectory Farm
in Northmoor.

## The Second World War: Wartime Aerodromes

In 1940, new aerodromes were established at various places in and around Oxfordshire, including Akeman Street, Chipping Norton, Cowley, Golder Manor, Kiddington, Mount Farm, Stanton Harcourt and Watchfield. Further airfields were subsequently opened at Fairford, Kelmscott, Broadwell, Barford St John, Barton Abbey, Harwell, Burford, Chalgrove, Culham, Edge Hill, Grove, Kingston Bagpuize, Little Rissington, Shellingford, Slade Farm, Starveal Farm, Thame and Windrush. *Above:* Flt-Lt 'Ricky' Jones, a Battle of Britain pilot, became test pilot at Witney. *Below:* A DH Dominie at Witney Aerodrome.

## The Second World War: Upper Heyford Aerodrome

Situated on a windswept site some 421 feet above mean sea level, Upper Heyford Aerodrome was opened in 1916, and it was used by several different squadrons during the interwar years. The aerodrome became a Bomber Command training station in the Second World War, the resident unit being No. 16 OTU, which was equipped with Hampdens, Herefords, Wellingtons and Ansons. Upper Heyford became an American base in 1951, and, as such, it remained in use until the end of the Cold War. The pictures were taken in 2013.

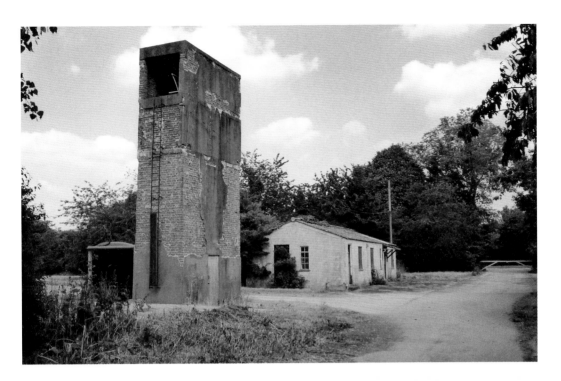

## The Second World War: Stanton Harcourt Aerodrome

Stanton Harcourt airfield was constructed in 1940 as a satellite of RAF Abingdon. The airfield was used by twin-engined Bomber Command aircraft, including Wellingtons and Whitley Bombers, and in 1942, it took part in the first Thousand Bomber Raid on Germany. The airfield was associated with No. 10 Operational Training Unit for most of the war, though other units, such as No. 1 Blind Approach Training School, used its facilities from time to time. The layout incorporated a main runway that was aligned north-east to south-west, with subsidiary runways extending northwards and north-westwards respectively. The sepia picture shows one of three prehistoric standing stones, known as 'The Devil's Quoits', which were buried beside the runways when the airfield was built, while the colour photograph shows the entrance to the long-abandoned aerodrome in 2013 – the disused guardhouse is still more or less intact.

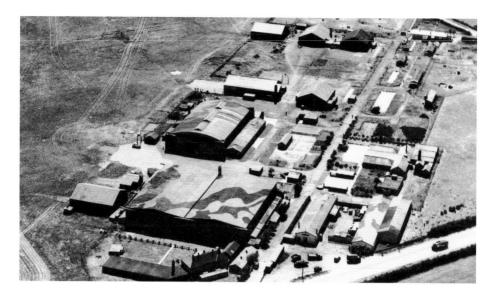

## The Second World War: Witney Aerodrome

Witney Aerodrome, which became a civil airfield after the First World War, was taken over by the Air Ministry at the start of the Second World War. In 1940, de Havilland opened a civilian repair unit (CRU) on the site, aircraft being flown in for repair, or conveyed in RAF transporter vehicles. In all, the CRU at Witney repaired over 700 Hurricanes and Spitfires, together with around 800 de Havilland aircraft, including Mosquitoes, Tiger Moths and Rapides. *Above:* At the end of the Second World War, the aerodrome consisted of a grassed landing strip, with a cluster of three hangars and other buildings at the north-western corner of the site. No. 1 Hangar was the former First World War building, with its distinctive Belfast truss roof, while Nos 2 and 3 Hangars were standard Second World War, steel-framed structures. A much smaller building, to the north of Hangar No. 1, was known as the Survey Hangar, while other buildings included a paint shop, battery shop, fitting shop, drawing office and canteen. The domestic site, to the west of the airfield proper, was used as an Army camp during the Second World War. *Below:* Serving tea in the airfield canteen.

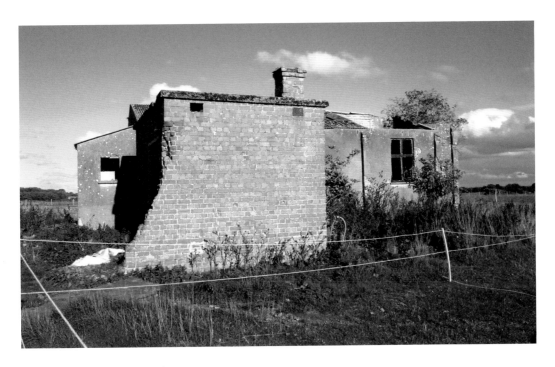

### Akeman Street Aerodrome

RAF Akeman Street was opened in June 1940 as a relief landing ground for Brize Norton. It was situated near Crawley, on the Roman road from which it derived its name. There was a grass-covered landing area within a perimeter track, together with ten single-arc 'Blister' hangars, and a more substantial hangar of the rectangular 'Bellman' type. The airfield had closed by 1946, and the site has reverted to agricultural use, as shown in the accompanying photographs. The derelict building was probably a tractor shed.

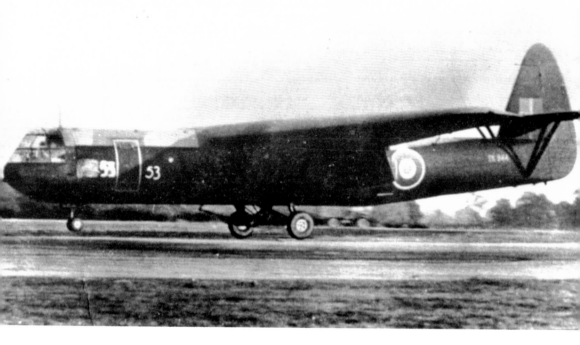

## The Second World War: The Build Up to D-Day

The second phase of the war was dominated by the build up to D-Day and, by 1944, Oxfordshire had become a major flying training region. Brize Norton, Broadwell, Kidlington and other local aerodromes were now intimately connected with airborne warfare, and in the months before D-Day, Whitley and Albemarle bombers could often be seen towing wooden Horsa gliders in the skies around Oxford. The upper view shows a Horsa taking off, and the lower picture is a glider pilot's view of a Halifax 'tug'. *Inset:* As airborne troops, members of the 2nd Battalion Oxfordshire & Buckinghamshire Light Infantry sported maroon berets, the bugle horn badge being worn on a dark green patch.

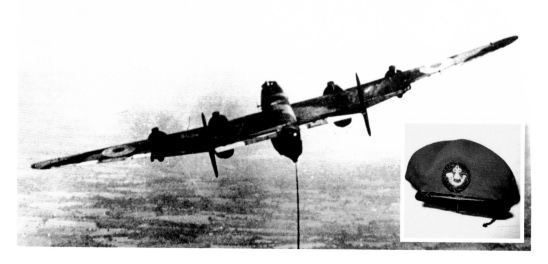

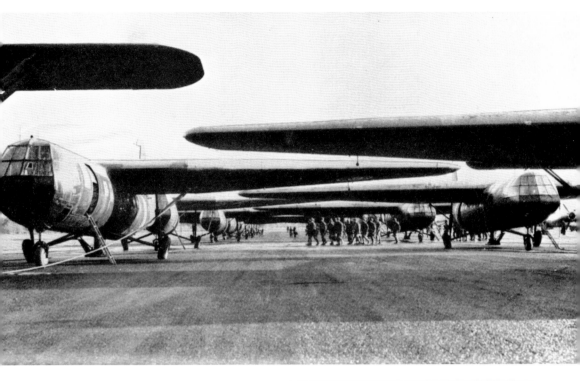

## The Second World War:
## The D-Day Invasion

In June 1944, Brize Norton and Broadwell airfields participated in the long-awaited D-Day invasion, sending large numbers of Albemarles and Dakotas to the Normandy battlefields. Some airborne units parachuted in conventional manner, but others were towed in the Horsa gliders that had been familiar sights in the skies of Oxfordshire for the past few months. The 2nd Battalion Oxfordshire & Buckinghamshire Light Infantry, which had been an Air Landing Battalion since 1941, provided the first unit to land in Normandy on 5 June 1944, when a *coup de main* force flew from Harwell Aerodrome in six Horsas to capture the vital Pegasus Bridge over the Caen Canal. The upper picture shows Horsa gliders marshalled prior to take-off, possibly at Broadwell, while the right-hand view shows three Horsas beside Pegasus Bridge. *Inset:* Members of the 6th Airborne Division and other British airborne forces wore a cloth shoulder badge depicting Bellerophon riding Pegasus, the winged horse, symbolising warriors who arrive from the air.

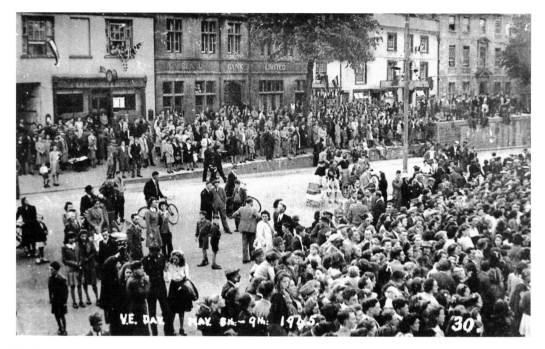

V.E. DAY MAY 8th-9th: 1945.  30.

## The Second World War:
## VE Day – the End of the War in Europe

Having crossed the Rhine, the Allied forces advanced rapidly across Germany, and the 43rd Light Infantry was in Hamburg on VE Day, 9 May 1945. Many of those serving in 1945 had been with the regiment since 1940. Pte Reginald Green, for example, had served throughout most of the war, but when interviewed in the 1990s, he refused to talk about his wartime experiences, making only one comment: 'I went into the Oxon & Bucks in March 1940. Done six years in the Army. I was in France, Belgium, Holland, then up to into Germany. We was just outside Hamburg when the war finished. They said we'd got some special news coming through in the morning, then they said the war was over – Hooray.'

Meanwhile, Germany's Japanese allies had suffered heavy defeats. In July 1945, the Allies called upon Japan to surrender or face total destruction, and in August 1945 the cities of Hiroshima and Nagasaki were obliterated by Atomic bombs. The Japanese surrendered at midnight on 14/15 August 1945, and the Second World War was brought to an end.

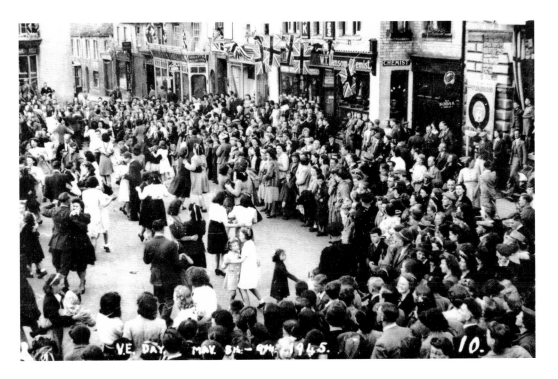

### The Second World War: VE Day

*Above:* A further glimpse of VE Day celebrations at Witney. Phyllis Ransom recalled that 'people surged out of their houses when evening fell, and with one accord made for the Square ... to me the most joyful sound to fill the Square was the ringing of the long-silent church bells'. *Below:* VE Day celebrations under way outside the Sadler's Arms pub in New Yatt, the village children having been assembled for the photographer.

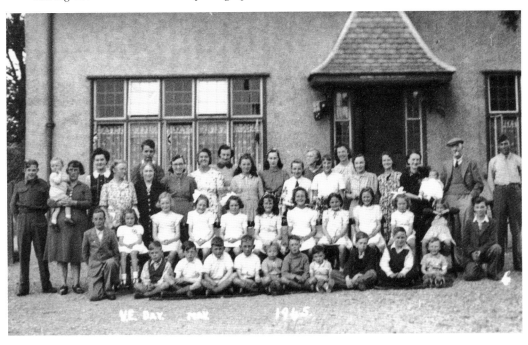

## Postscript

Despite the severe rundown of Britain's armed forces in recent years, Oxfordshire retains a major RAF station at Brize Norton, together with Army depots at Bicester, Abingdon and Didcot. Wartime aerodromes and other military installations have left substantial remains throughout the local countryside, as exemplified by these final views of Stanton Harcourt (*above*) and Upper Heyford aerodromes (*below*). Both of these photographs were taken in the summer of 2013.